BURTON'S LOST BREWERIES

From Old Photographs

TERRY GARNER

AMBERLEY

First published 2017

Amberley Publishing
The Hill, Stroud
Gloucestershire, GL5 4EP

www.amberley-books.com

British Library Cataloguing in Publication Data.
A catalogue record for this book is available from the British Library.

ISBN 978 1 4456 7538 1 (print)
ISBN 978 1 4456 7539 8 (ebook)

Origination by Amberley Publishing.
Printed in the UK.

Contents

Introduction

Burton's brewing heritage has been documented superbly over the years, but a pictorial record of its breweries that have disappeared, I thought, would be of interest. A large proportion of these images depict views of Bass and Ind Coope, simply because these two giants of the brewing trade chronicled their operations more than the smaller companies. Quite a number of these smaller brewers were only in existence for a short space of time before they were either absorbed by the 'big boys' or simply went out of business altogether. Brewing processes, however, operated almost identically in all breweries, so any images from the smaller companies would have been very similar should they have survived. While most of the images within these pages will be familiar to lots of former brewery workers, it gives the general public an insight into the breweries that they wouldn't normally be able to see. All of the pictures come from my own personal collection, except where indicated – for these, I am most grateful for the permission to use them.

Bass Brewery

Bass New Brewery in Station Street, where brewing is due to cease in 2017, followed by demolition.

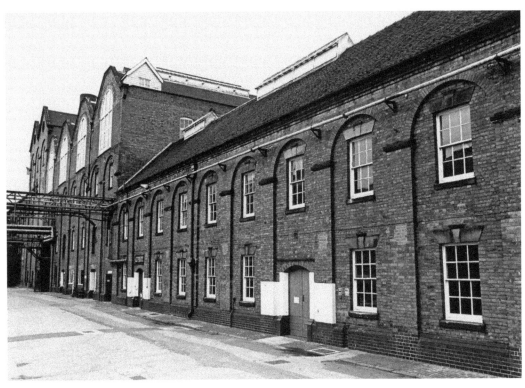

Further back into the brewery, the boiling house and cooling rooms.

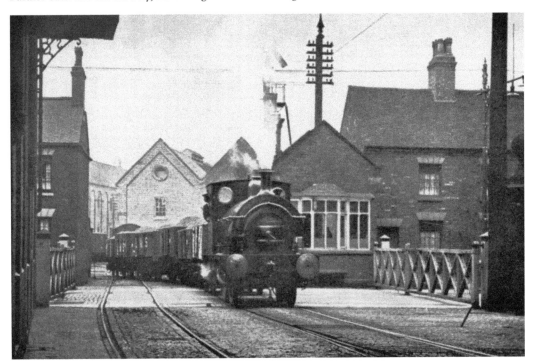

One of the internal crossings, this coming from the Bass Middle Yard across to the New Brewery.

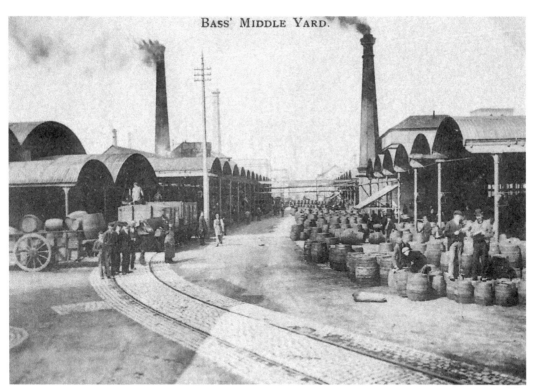

Floaters, rail wagons and hundreds of casks would run the whole length of the Middle Yard.

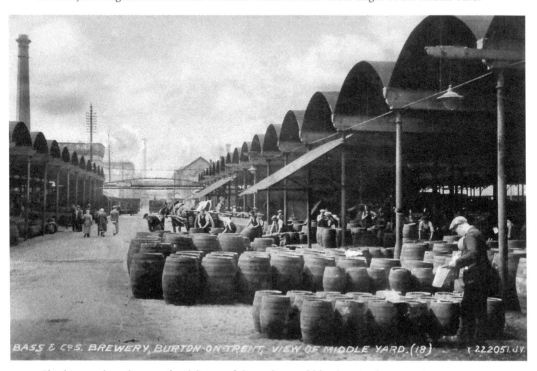

BASS & COS. BREWERY, BURTON-ON-TRENT, VIEW OF MIDDLE YARD. (18) 22205, JV

Checking and marking up for delivery of the casks would be done in the open air.

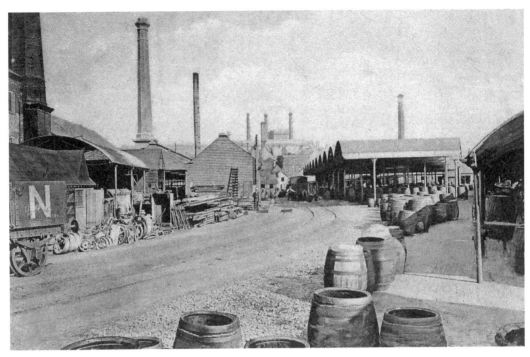

Looking into the Cooperage Yard from High Street, with staves and hoops littering the ground, but all accounted for.

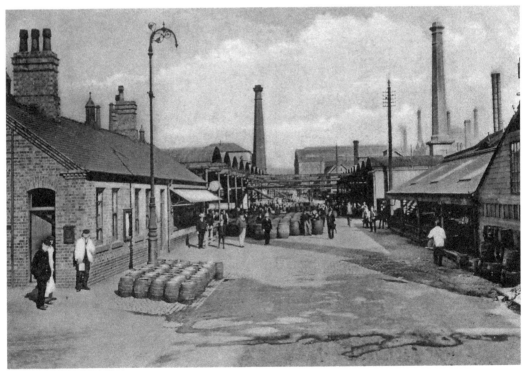

Middle Yard staff would always stop to accommodate photographers whenever they came on site.

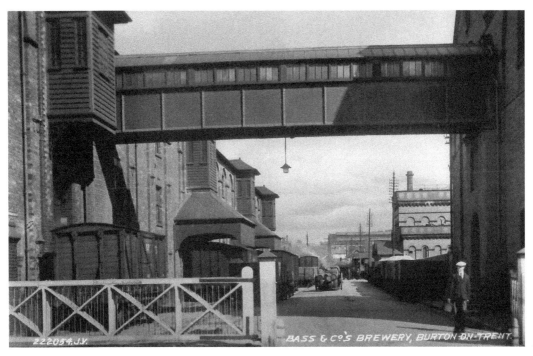

The Guild Street entrance connecting the Middle Yard to High Street.

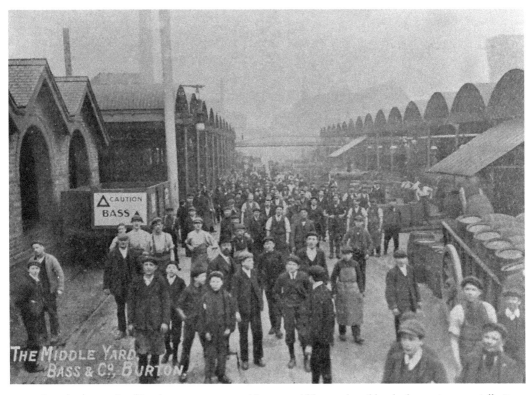

A perfect example of just how many men and boys would be employed by the breweries, especially Bass.

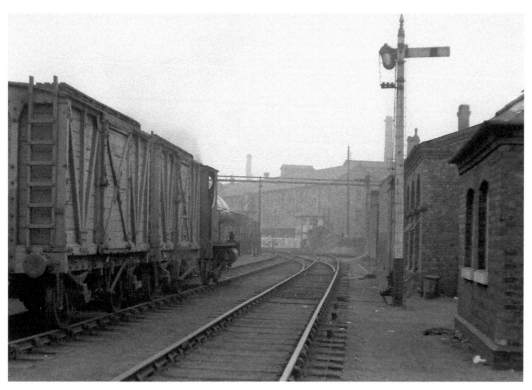

One of the busiest crossings was this one in Guild Street that the loco and wagons are heading for.

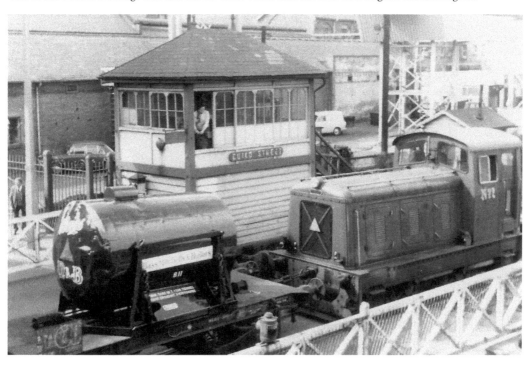

This is the same crossing, but diesels have now replaced steam locos. The signal box has a female operative.

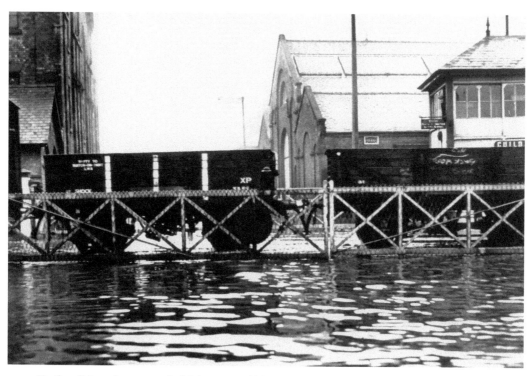

Until well into the 1960s, Guild Street would be under floodwater several times during the year, but they still managed to get the beer out.

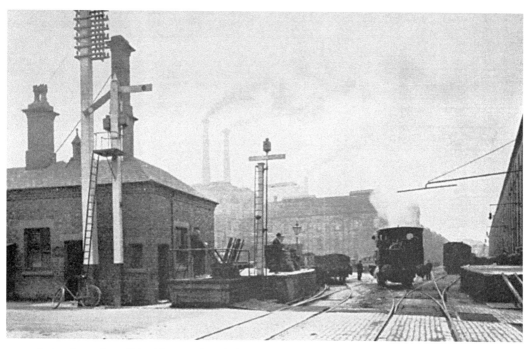

A signal crossing off Guild Street that dealt with the internal traffic to and from the Delhi Maltings to the right.

Bass canister plant with two three-wheeled Scammell Mechanical Horses.

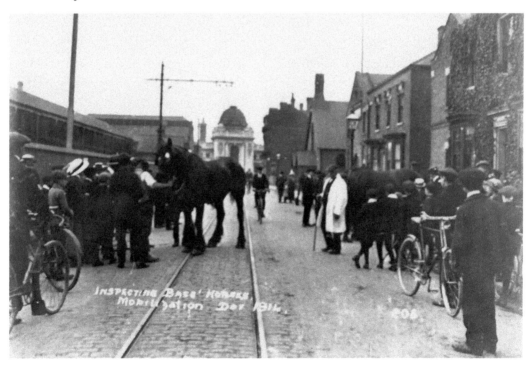

Brewery horses were mobilised to go to France and Belgium to help with the First World War effort. Some can be seen here being examined off-site in Guild Street.

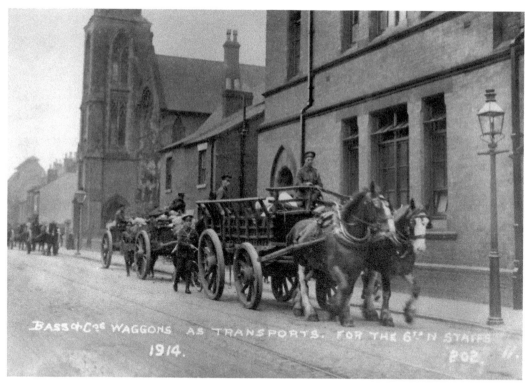

Another view of Guild Street. Grain wagons and floaters have been commandeered.

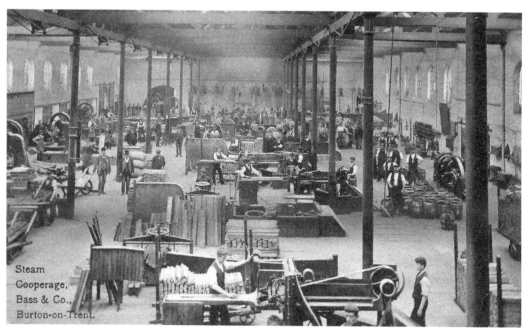

Above and overleaf: Seasoned oak was used for all wooden items within the breweries – staves for casks, bungs, pegs, etc. Huge amounts of oak would have been used, as evidenced here in the Steam Cooperage site. It was later converted to be run by electricity.

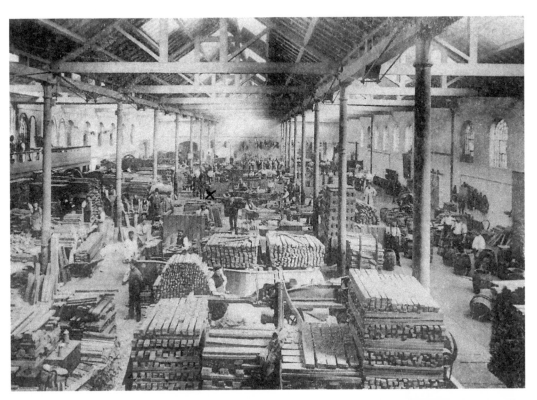

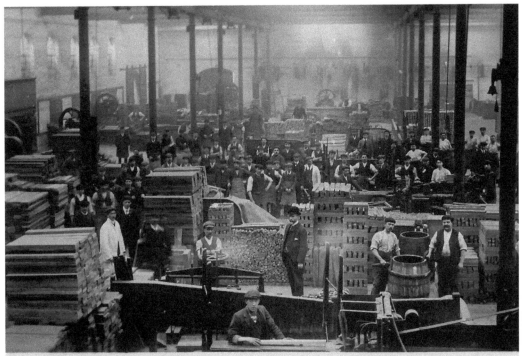

15794 STEAM COOPERAGE, BASS'S BREWERY, BURTON-ON-TRENT.

14

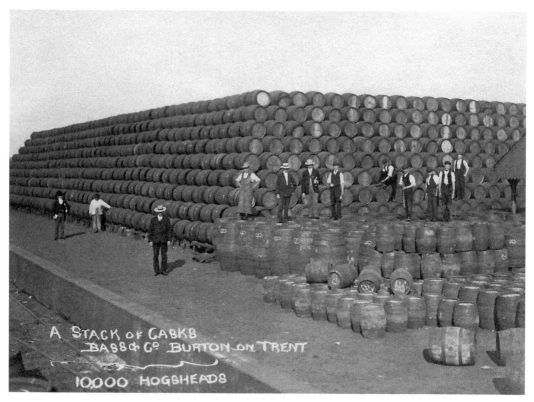

Although the title says Hogsheads (54 gallons), not all of these casks are – even so, a stacking headache.

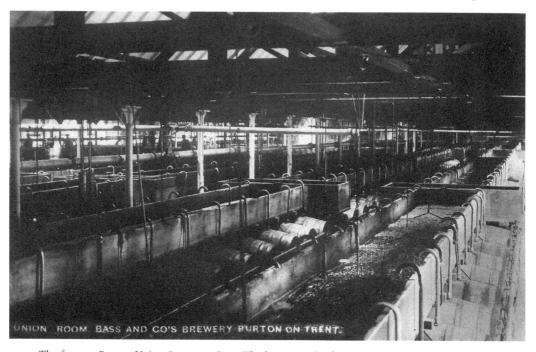

The famous Burton Union System at Bass. The beer is at the fermentation stage at this point.

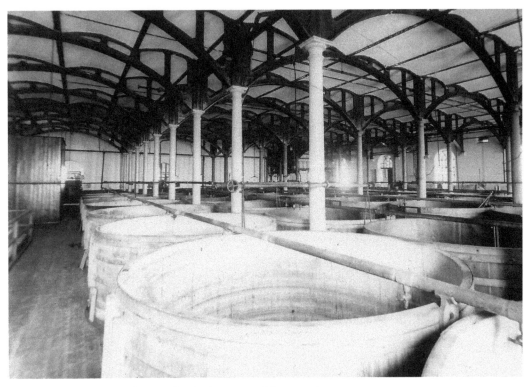

Open 'rounds' are unusually quiet for the first stage of fermentation.

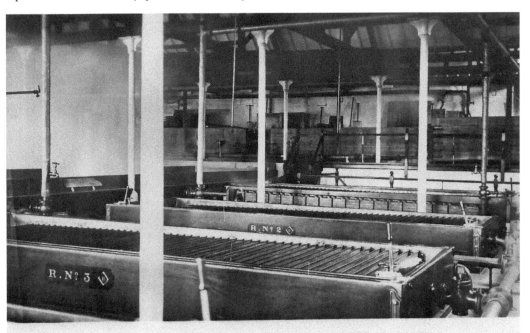

15797 COOLING ROOM, BASS'S BREWERY, BURTON-ON-TRENT.

Before the yeast is added for fermentation the hot wort needs to have the temperature reduced in the cooling room.

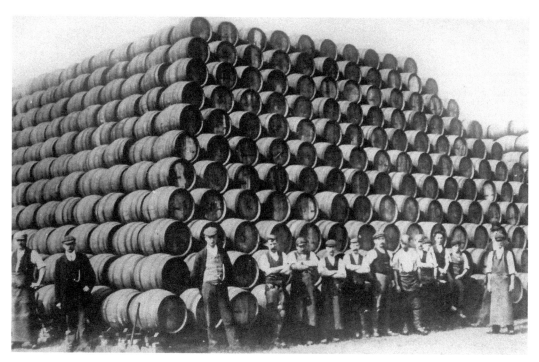

Bass coopers stand in front of an enormous pyramid of their work.

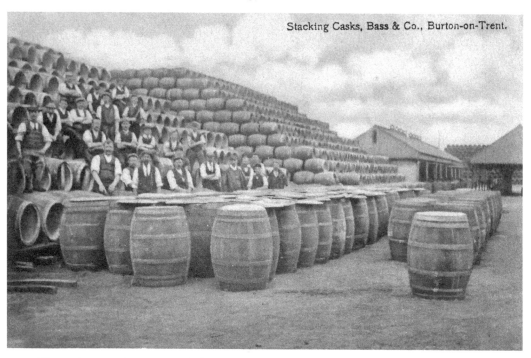

Stacking Casks, Bass & Co., Burton-on-Trent.

All over brewery sites men would be seen working on the casks.

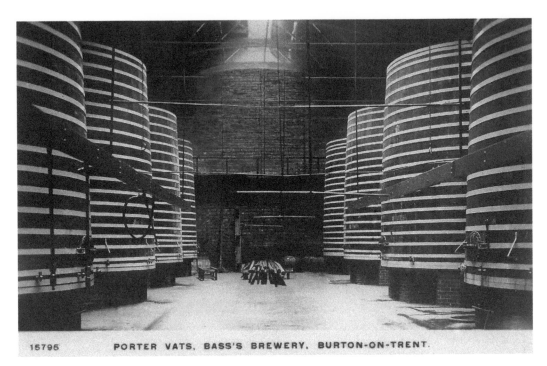

15795 PORTER VATS, BASS'S BREWERY, BURTON-ON-TRENT.

The huge porter vats at Bass Middle Yard site.

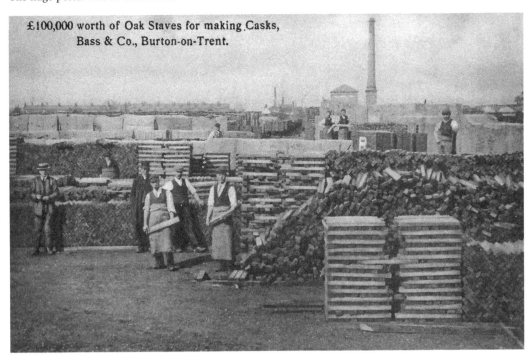

£100,000 worth of Oak Staves for making Casks,
Bass & Co., Burton-on-Trent.

Oak staves on arrival would be seasoned in the open air for two years before being used.

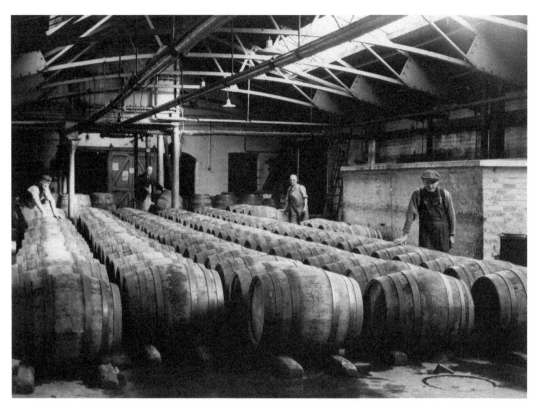

After filling, the cask would be kept in the cold rooms prior to distribution to trade.

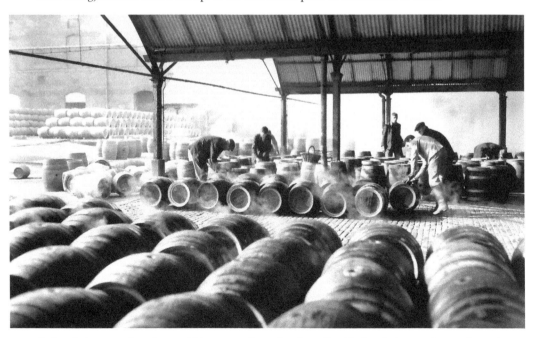

Before being reused, casks would be steam cleaned and sterilised before being smelt – as shown here – for freshness.

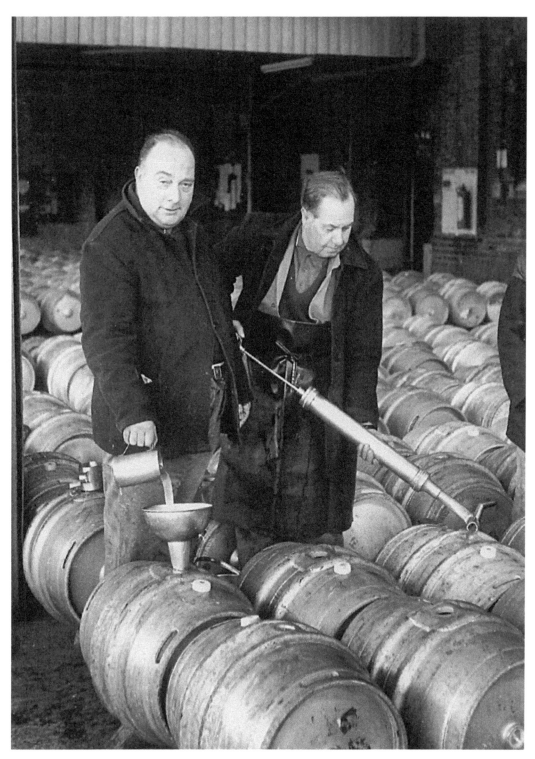

If any hops had been added to create a cask-conditioned ale, brewers finings would be added – as shown here – to clear the beer.

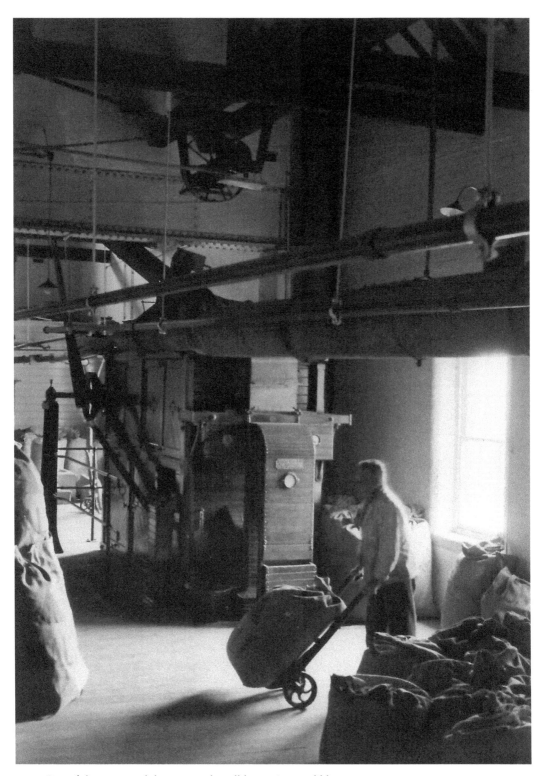

One of the many such hop stores that all breweries would have.

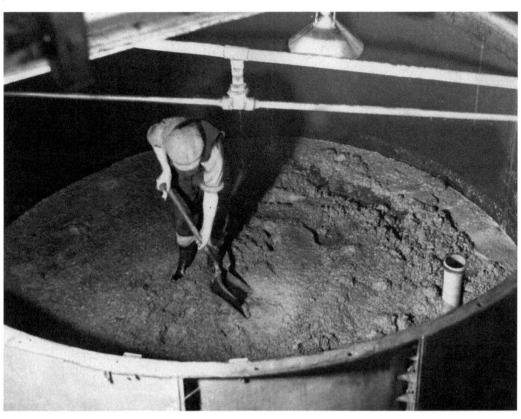

Mash Tuns always emptied manually – a very hot operation to perform. The mash going for animal feed.

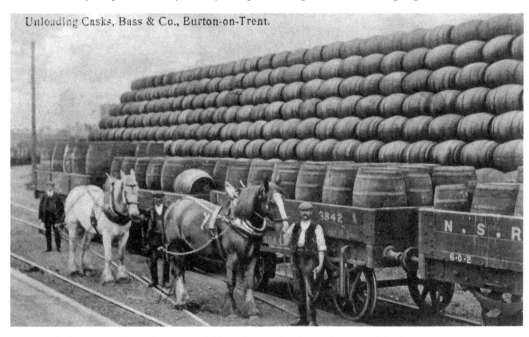

Up until the late 1950s heavy horses would have been a familiar sight around the breweries.

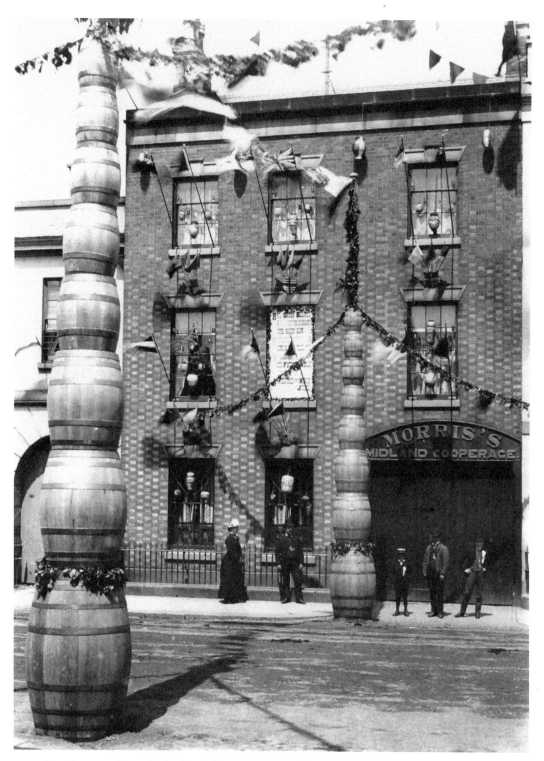

As well as most breweries having their own coopers, casks would also be supplied by outside cooperages. Morris' stood in Horninglow Street.

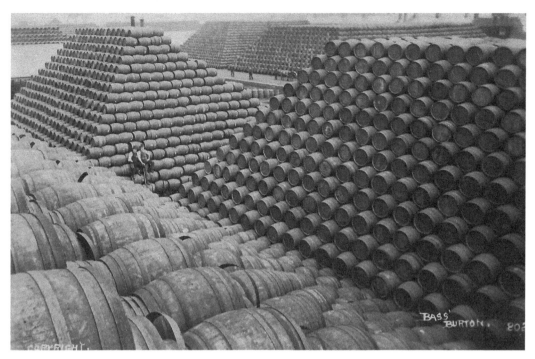

This would be a health and safety violation today, but in earlier days this would be a normality.

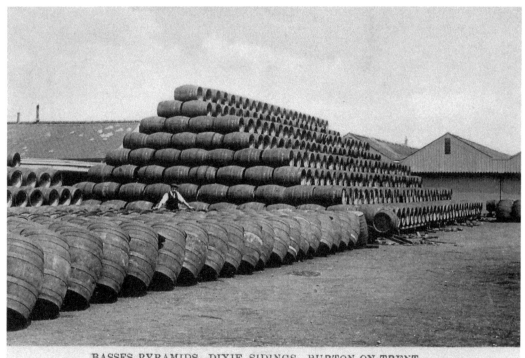

BASSES PYRAMIDS, DIXIE SIDINGS, BURTON-ON-TRENT.

Cask mountains could be seen all around the town. This one is located at Bass, Dixie Sidings, in Hawkins Lane.

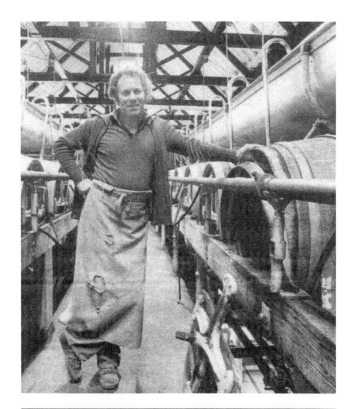

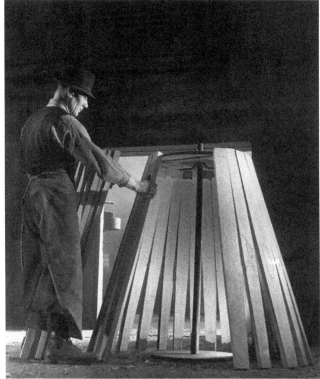

Right and overleaf: Master cooper Eddie Lee spent many hours with sculptor James Butler for him to create a life-sized statue of a cooper at work, assisted by another master cooper from Bass, Joe Foster. The figure now stands in the aptly named Coopers Square in Burton town centre.

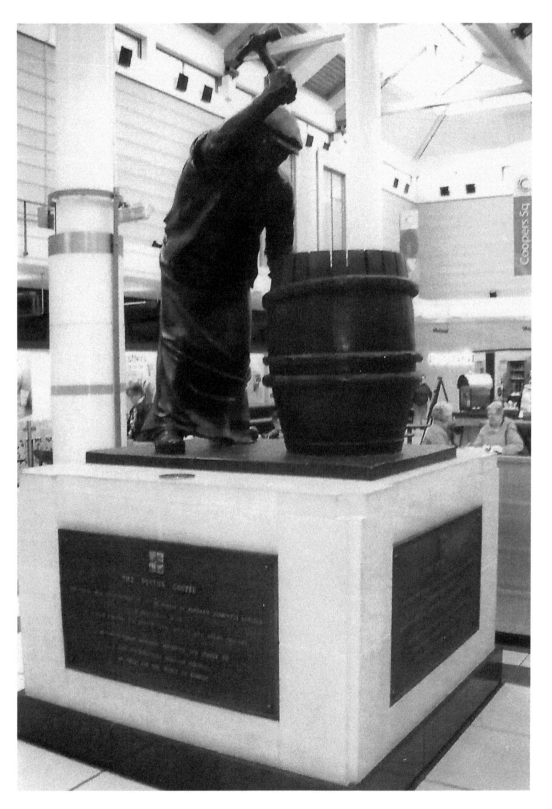

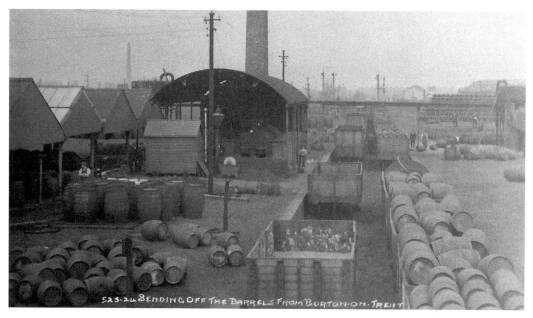

Ale loading docks are always busy. The boiler house is seen here open to the elements.

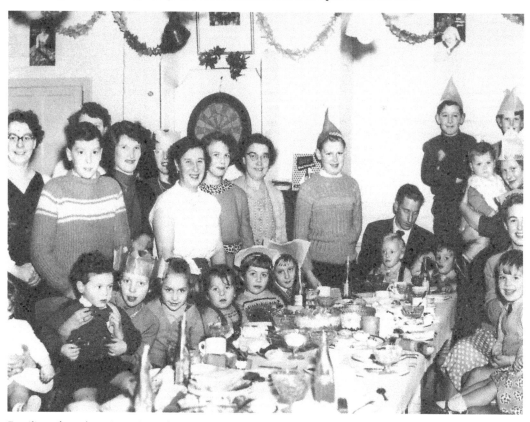

Families of workers in various departments were always treated well. Bass fire service provided a Christmas party every year for the children of the firemen.

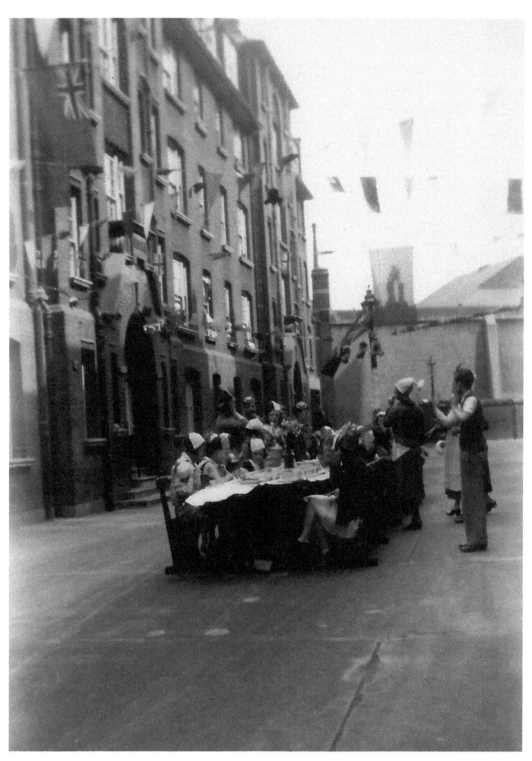

Estate workers weren't left out, they would be brought into the brewery for the function. Shown is the 1935 May jubilee party.

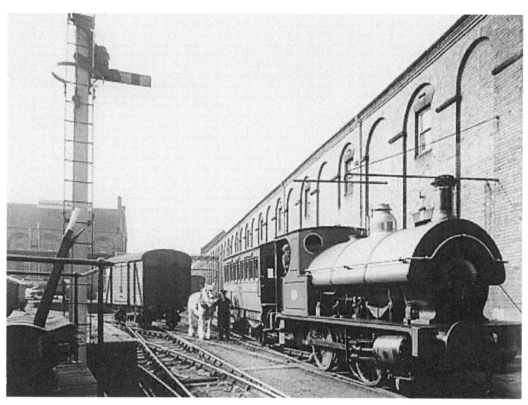

The last working shire at Bass: the grey, 17-hand Monty, pictured shortly before being retired.

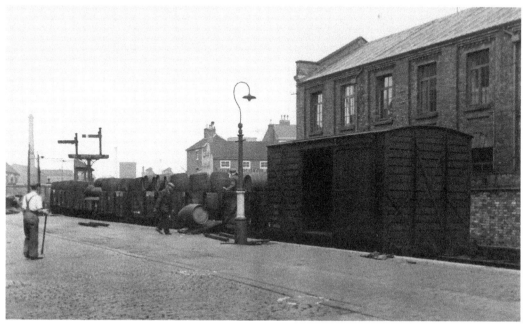

Ale docks were dotted all around the brewery sites. Shown is the Old Brewery dock, next to Eatoughs shoe factory in High Street.

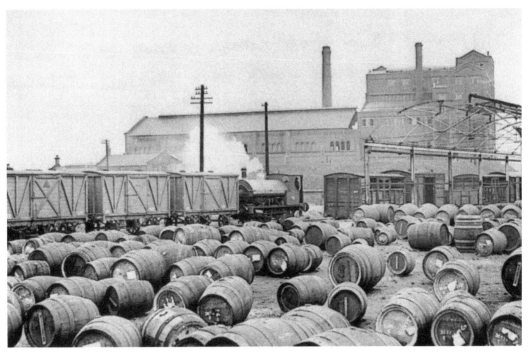

A chaotic-looking scene, but someone would know where all these casks were intended to be.

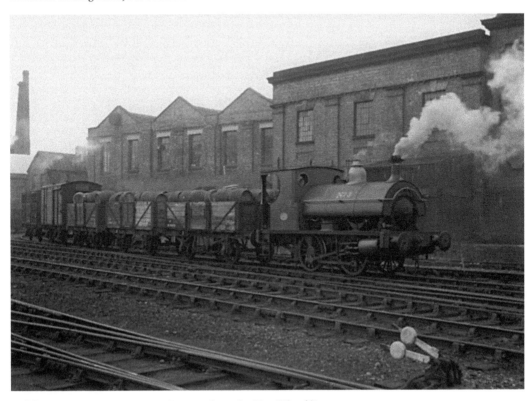

A delivery setting out on its way, leaving along the Hay Wharf line.

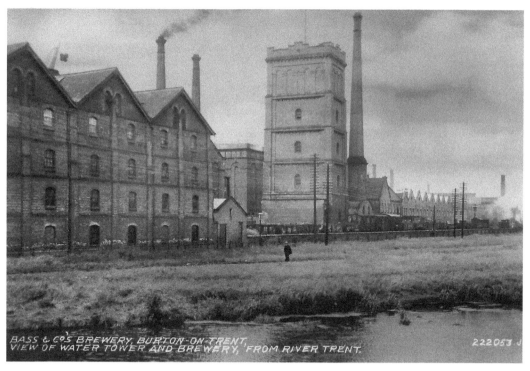

Another angle of the above picture. All that remains of this scene now is the Grade II-listed water tower.

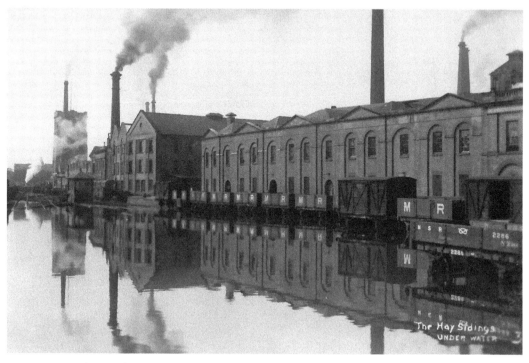

Being so close to the River Trent meant the sidings would have to deal with the lines getting flooded at times. This didn't stop the beer getting out.

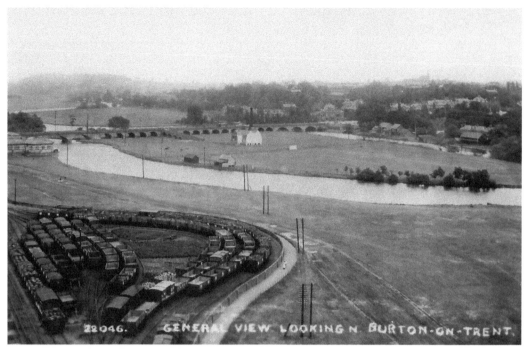

This image has been taken looking down from the water tower and clearly shows the marshalling yard.

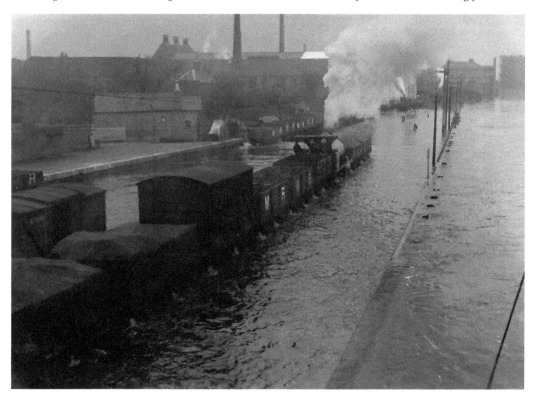

Floods were not a problem across in Wetmore Sidings.

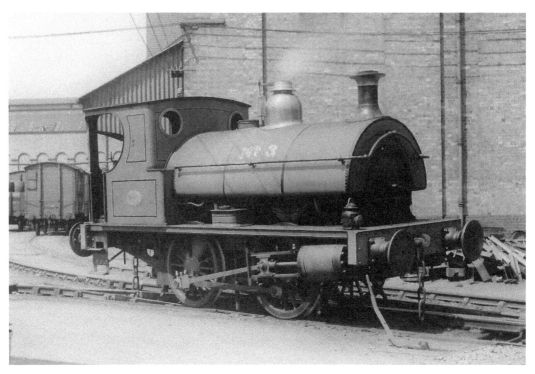

The workhorses of all rail deliveries were the reliable 0-4-0 saddle tank locos, as shown here by No. 3.

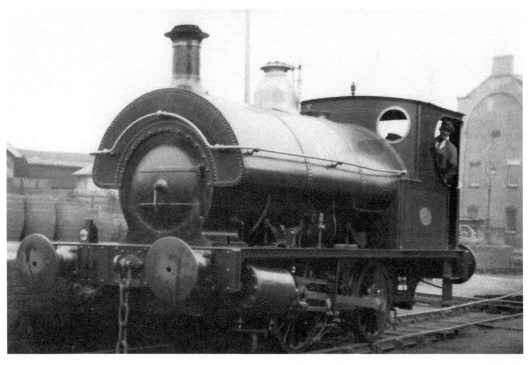

Bass (1777–2000) had nine of these locos. They were designed by the chief engineer in 1901, all built in Glasgow.

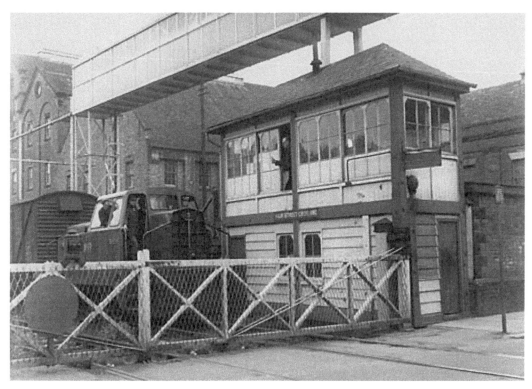

Diesel didn't replace steam until 1964.

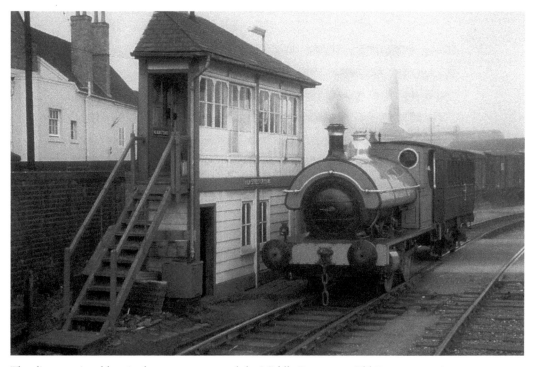

The slimmest signal box in the country operated the Middle Brewery to Old Brewery crossing.

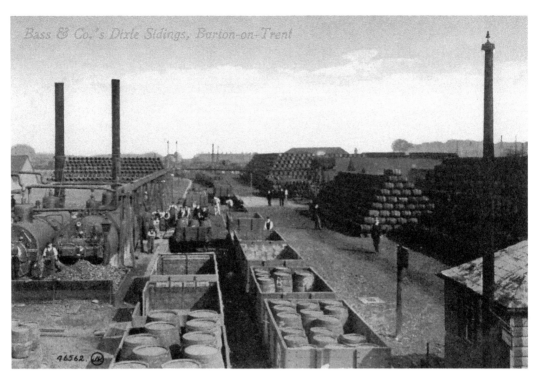

Dixie Sidings in Hawkins Lane covered a massive area, but the boiler house didn't have the luxury of a roof to protect the boiler man.

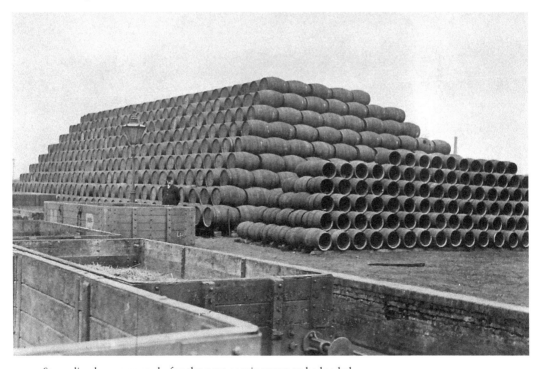

Straw-lined wagons ready for the next consignment to be loaded.

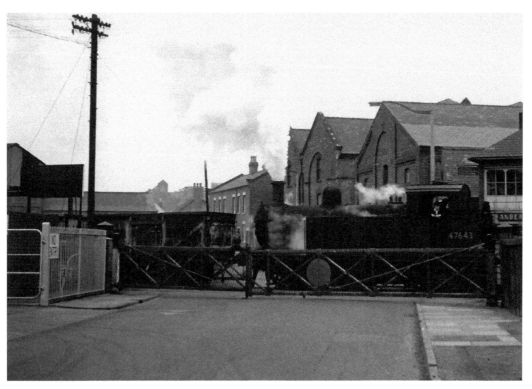

Not much road traffic was present when this shot was taken in Wetmore road.

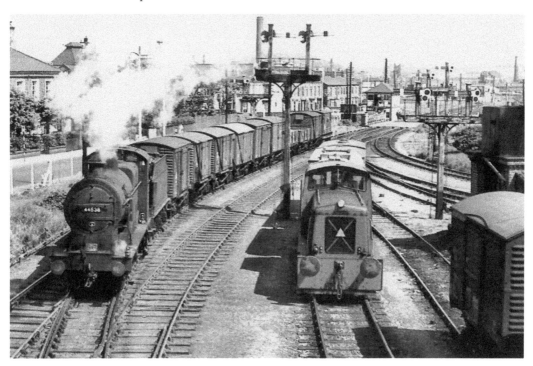

Junction lines at the entrance to Shobnall Malting site. The crossing signal box is just visible in the distance.

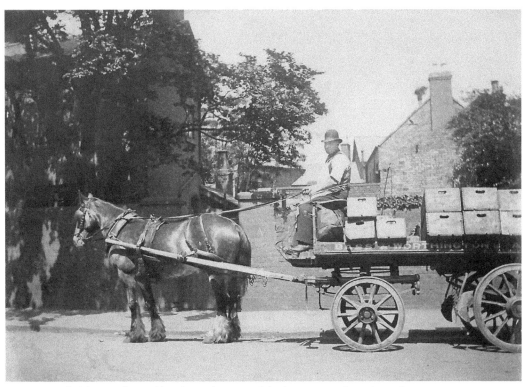

A small delivery of crated bottles at the start of the last century. Location unknown.

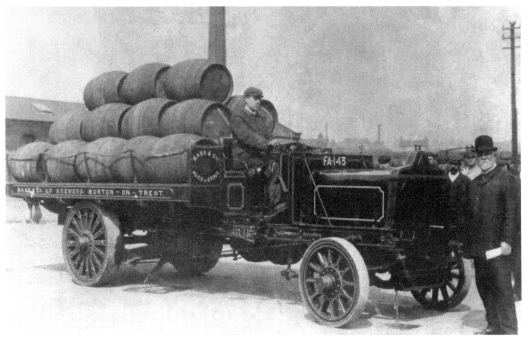

A new vehicle delivery to the brewery would warrant a photograph being taken. The registration at the time was FA for Burton.

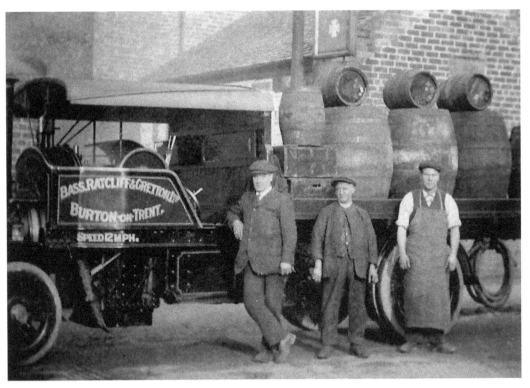

A steam lorry and crew pose just before heading out to deliver.

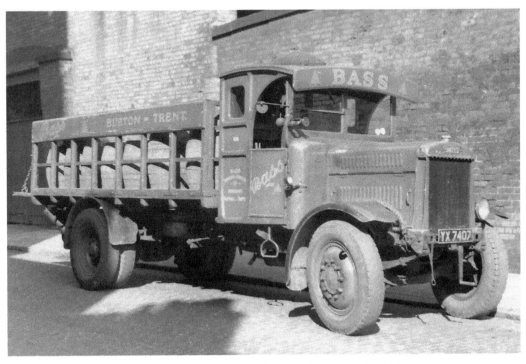

Deliveries from the main brewery to depots would be forwarded on by local vehicles.

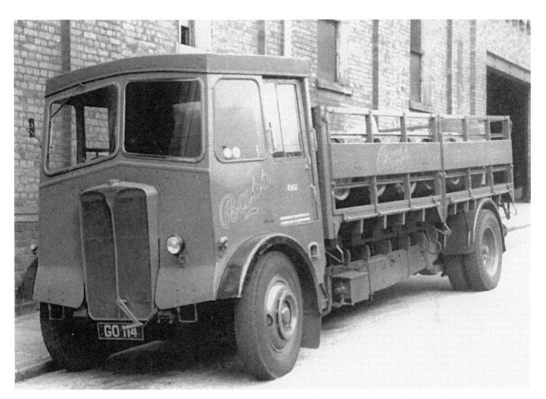

Different parts of the country would use different makes of wagons. The one shown was almost certainly at Liverpool.

Other Breweries

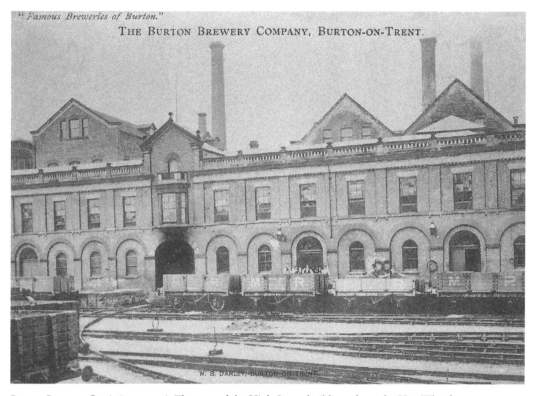

"Famous Breweries of Burton."

THE BURTON BREWERY COMPANY, BURTON-ON-TRENT.

W. B. DARLEY, BURTON-ON-TRENT.

Burton Brewery Co. (1842–1911). The rear of the High Street buildings from the Hay Wharf.

The Burton Brewery Co. premises on Bargates Corner awaiting demolition.

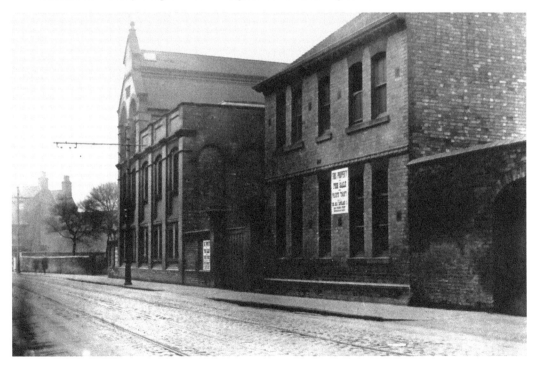

Bells Brewery in Lichfield Street closed in 1905 and was demolished shortly after.

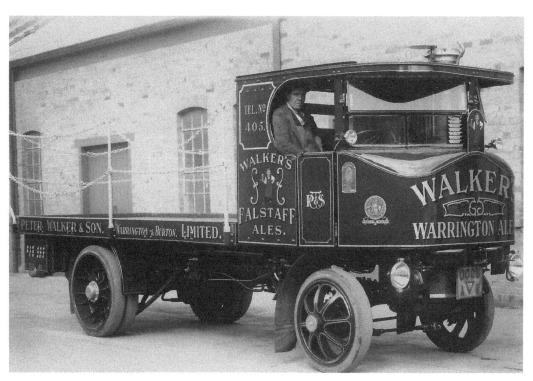

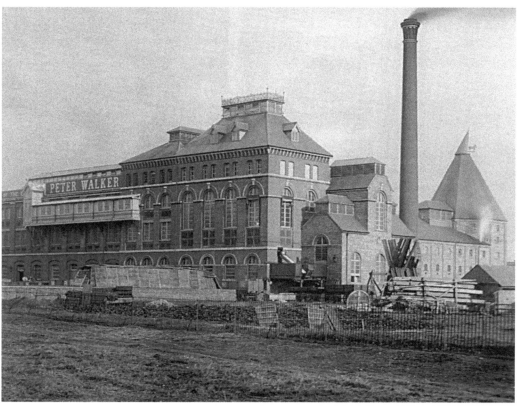

Above: The only photograph to be discovered of Clayton's Brewery (1875–95) on Horninglow Road South.

Opposite above: Peter Walker's steam delivery wagon posing in the brewery yard.

Opposite below: Peter Walker Brewery (1842–1926), located in Anglesey Road.

A. B. Walkers opened in 1877 (closure unknown). The office block is seen here in the then Wellington Street extension.

Horninglow Street brewery yard of Thompson & Son (1849–98), who later merged with Marstons.

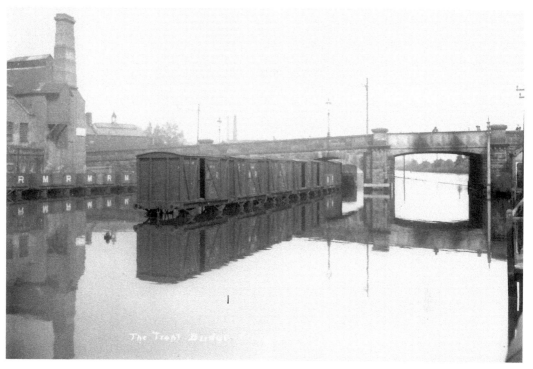

Nennerleys Brewery (1845–90) on the left, in Bridge Street, looking from the Hay Wharf.

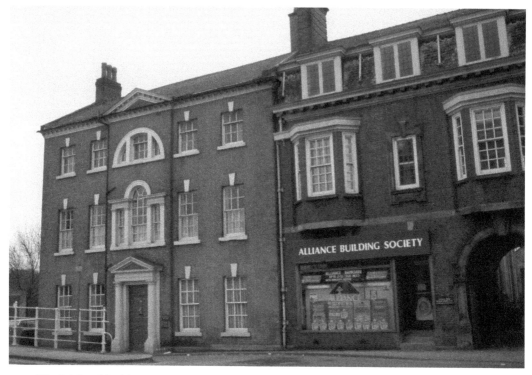

The left-hand building was Nunnerleys office block of Burton Bridge.

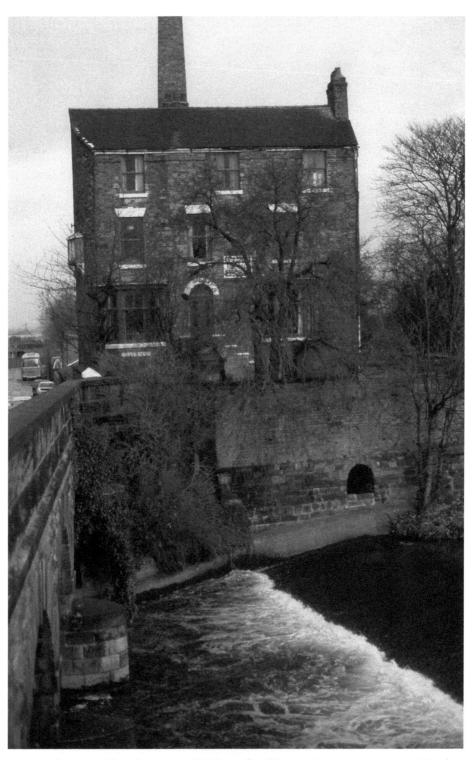

Above and opposite: The only surviving buildings of Boddingtons Brewery (1883–98) on Meadow Lane off Burton Bridge, which are now apartments.

J. Davis Brewery (dates unknown),
which was later taken over by
Marstons, stood in Horninglow Street.

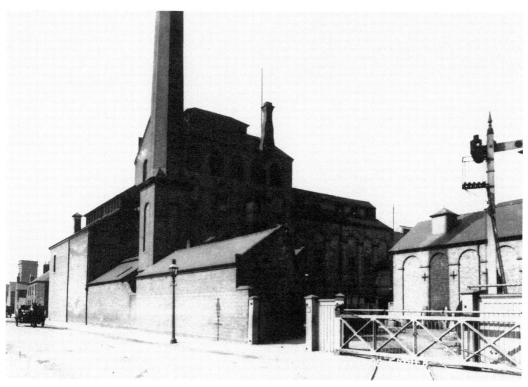

Looking from Duke Street, James Eadies Brewery (1857–1932) on the corner of Cross Street. They later amalgamated with Bass.

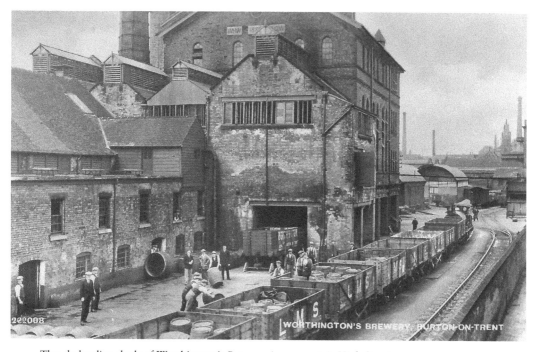

The ale-loading dock of Worthington's Brewery (1754–1965), High Street.

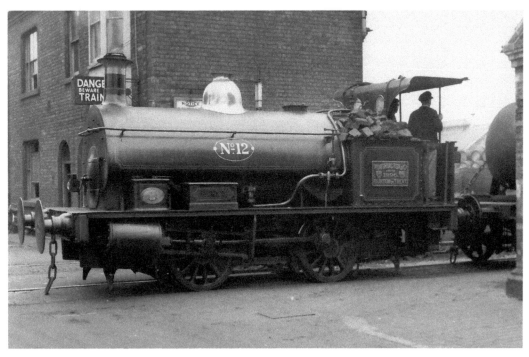

Worthington used 0-4-0 saddle tank locomotives, as did most breweries in the town. Here it is working in Bass Middle Yard.

The office block in High Street is the only part of Worthington's to have survived; it is now insurance offices.

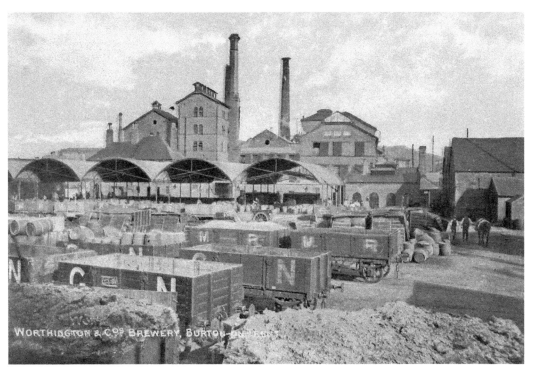

All this part of the brewery is now taken over by Burton Place shopping precinct and parking.

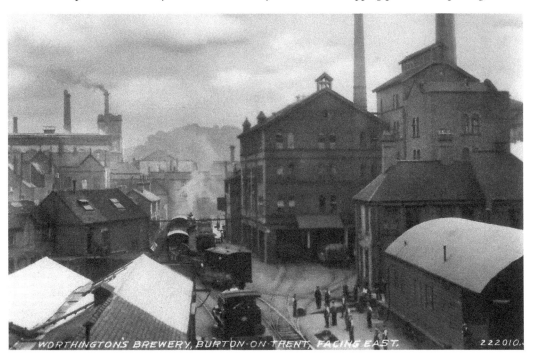

Looking back to the High Street crossing.

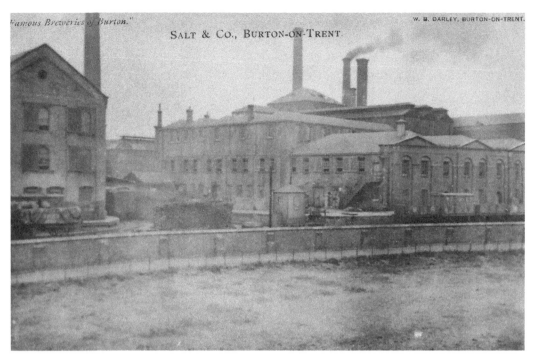

SALT & CO., BURTON-ON-TRENT.

Salt's Brewery (1800–1927) was also in High Street. The huge rear of the brewhouse building backed up to Hay Wharf.

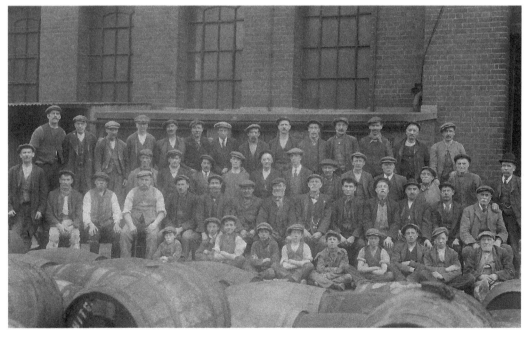

Part of Salt's workforce – men and boys – take time off to pose for the camera. Flat caps seem to be obligatory.

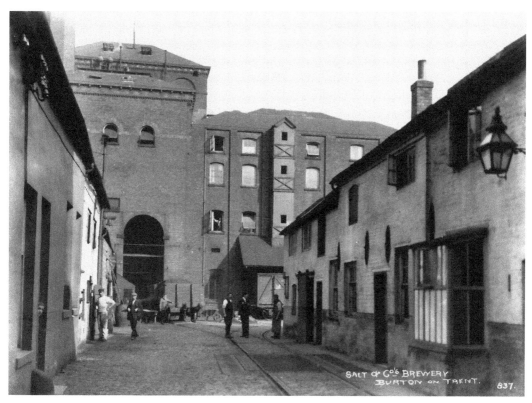

The rear of the brewhouse buildings. This was the entrance to the brewery from High Street. It is all now demolished.

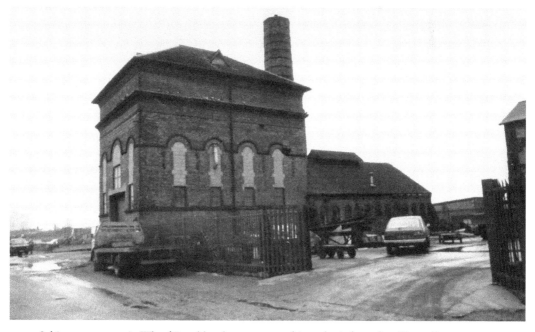

Salt's water tower in Wharf Road has been converted into the independent Tower Brewery.

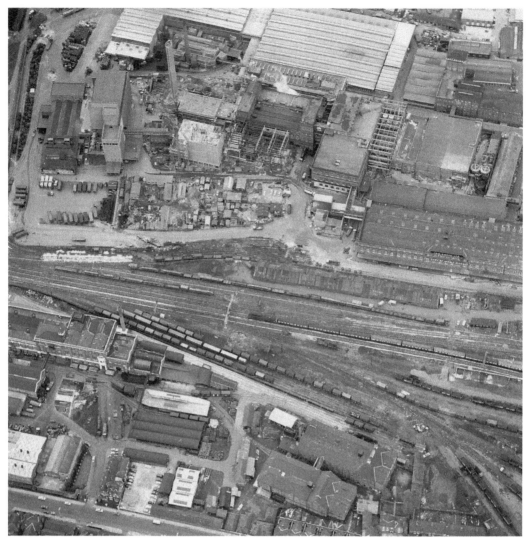

A fine aerial view of both Truman's Brewery and Ind Coope Brewery, along with the main line running between the two. Truman's is at the bottom of this view.

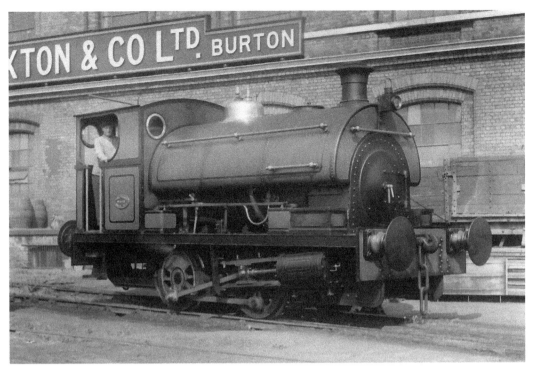

Truman's 0-4-0 locomotive posed at the rear of the brewery.

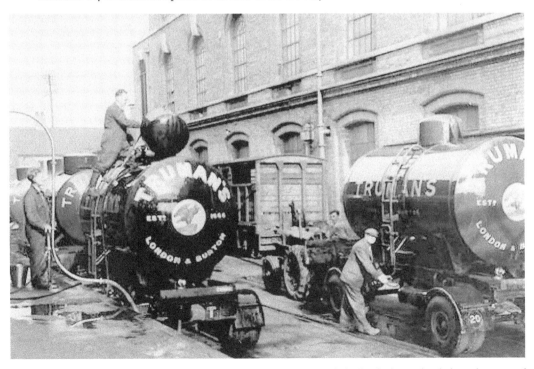

Road transport is beginning to replace deliveries here, with bulk ale being loaded to the rear of Derby Street.

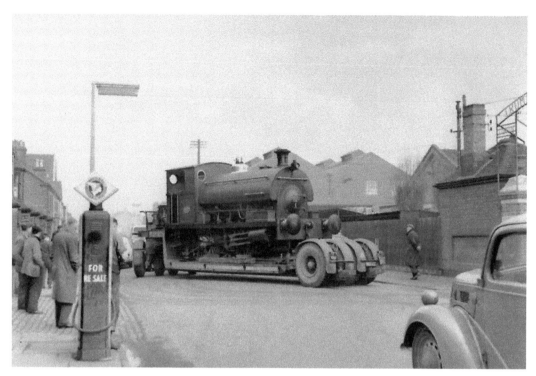

Truman's last locomotive can be seen leaving the brewery, going to preservation. The gateway is just visible to the right.

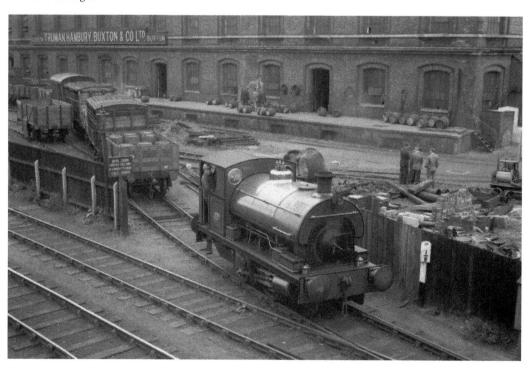

The close proximity to the main line meant deliveries would soon be on their way.

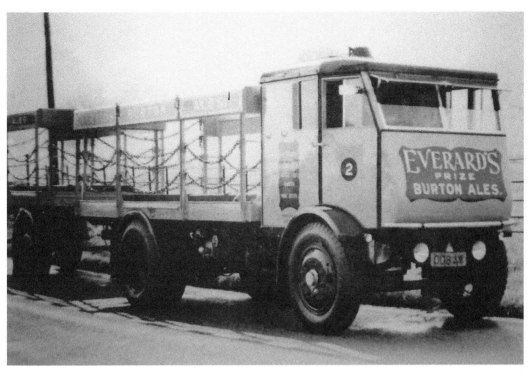

Everards (1885–1984), the Leicester brewery, had their Tiger Brewery in Anglesey Road. Lorries such as this one would operate between the two breweries daily.

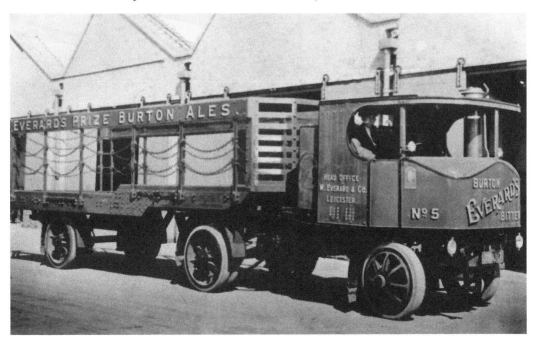

Another of the delivery vehicles used; this is an early steam wagon.

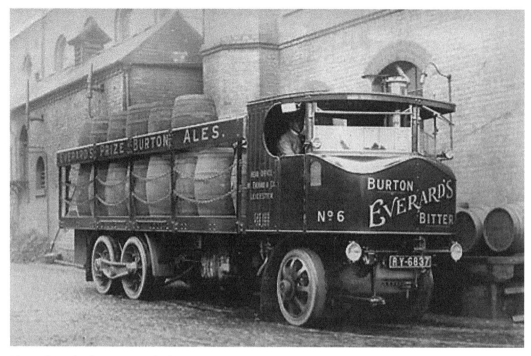

Pictured in the brewery yard, this rear twin-anxled lorry with fourteen barrels would only be partially loaded.

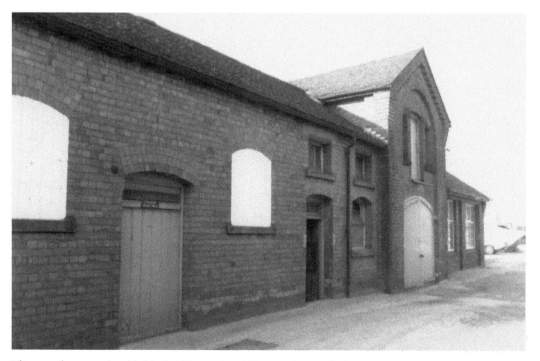

This was the original stable block of Everards, which was close to the brewhouse.

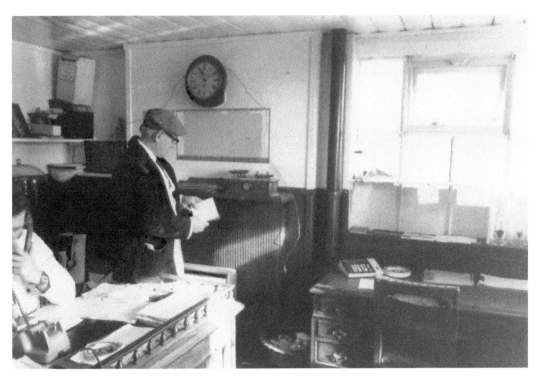

The foreman and manager planning the day's operation in the brewhouse.

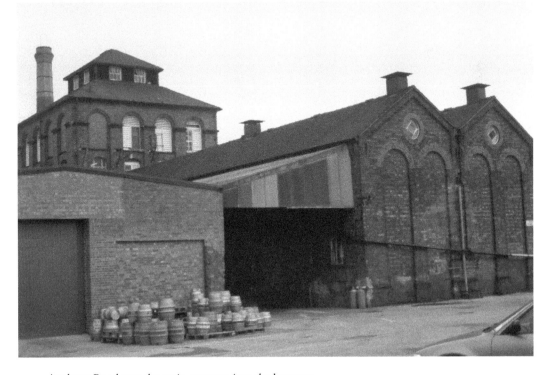

Anglesey Road was the main entrance into the brewery.

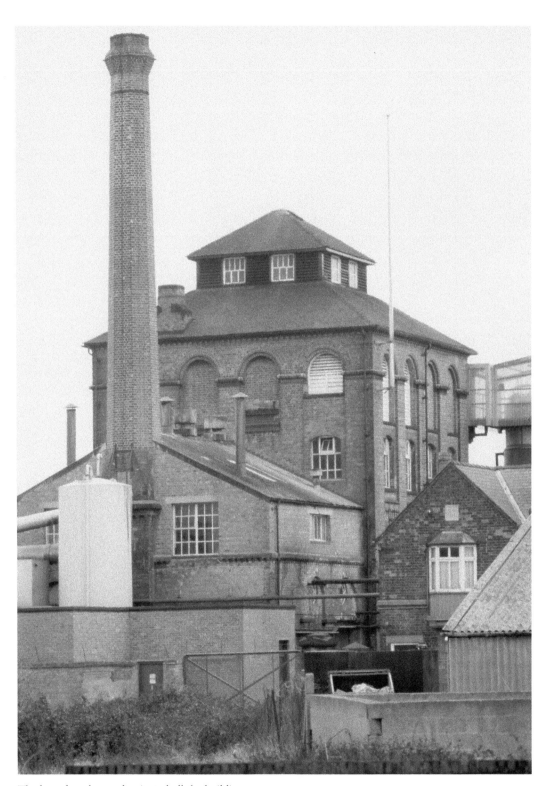

The huge brewhouse dominated all the buildings.

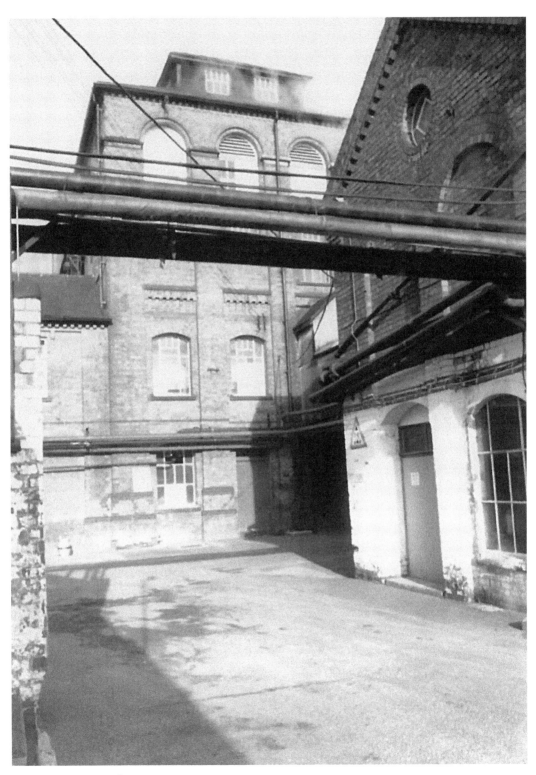

The rear internal view.

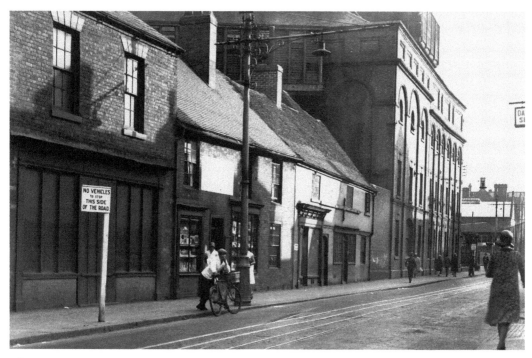

Allsopp's lager brewery ceased lager production from the High Street site in 1937, moving operations to Station Street.

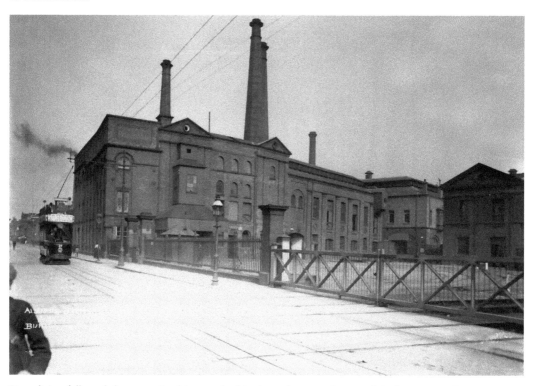

Demolition followed the move. Looking north, this shows how much ground the brewery took up.

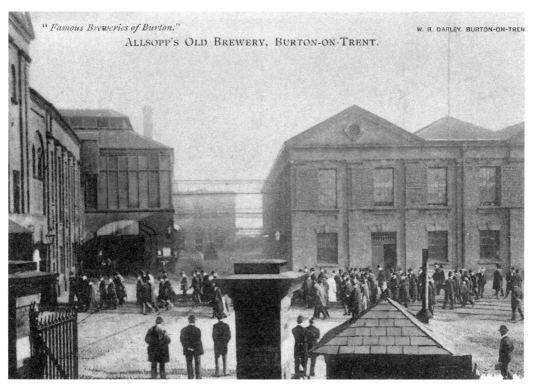

A large party of visitors have just arrived by internal loco for a tour of the premises.

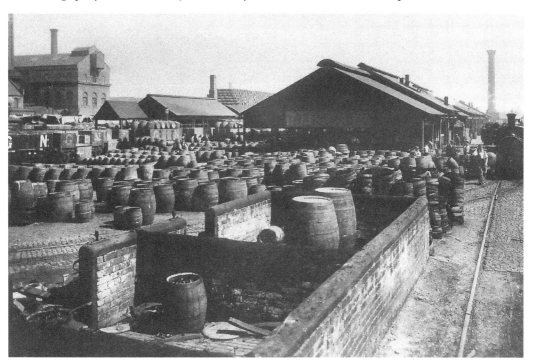

Various sizes of casks in the vast Allsopp's cooperage yard.

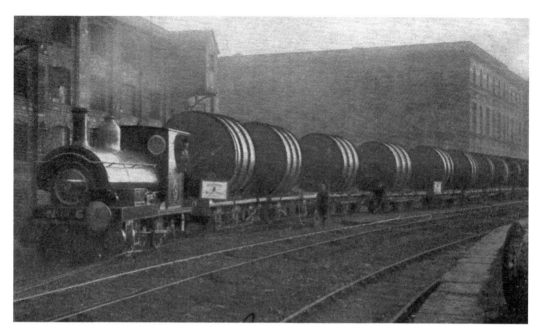

A new consignment of lager vats being delivered to the Station Street site.

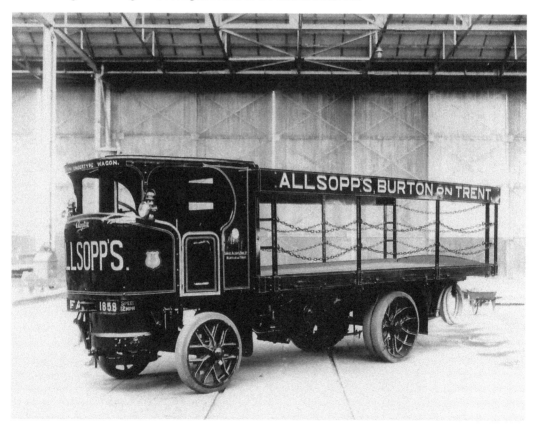

As with other breweries, steam delivery wagons made up most of the fleet.

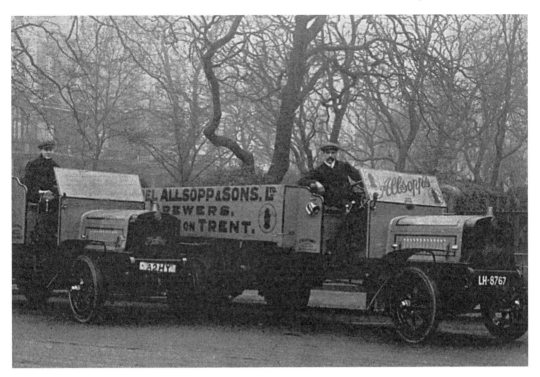

Two later vehicles about to be delivered to Allsopp's.

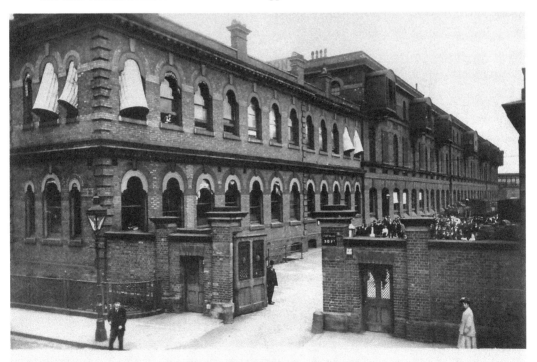

S 3942 ALLSOPP'S DINNER HOUR, BURTON-ON-TRENT

As the title explains, it is dinner hour here and it seems the whole workforce were leaving the premises.

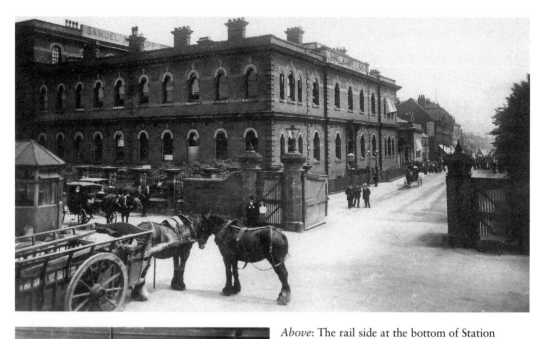

Above: The rail side at the bottom of Station Bridge, where brewery floats wait patiently.

Left: The huge amount of lager vats show how production had grown.

ALLSOPP'S LAGER CELLAR. BURTON-ON-TRENT

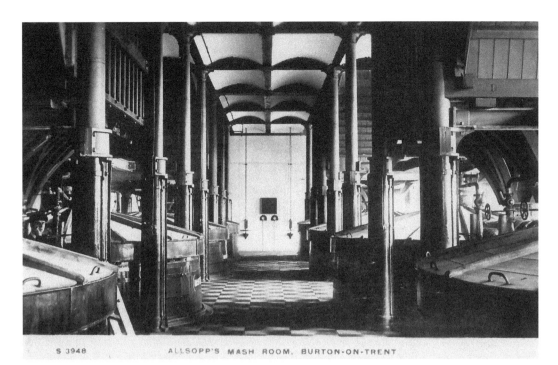

S 3948 ALLSOPP'S MASH ROOM, BURTON-ON-TRENT

The mash room can be seen here in a pristine condition; at other times it would have been a very busy department.

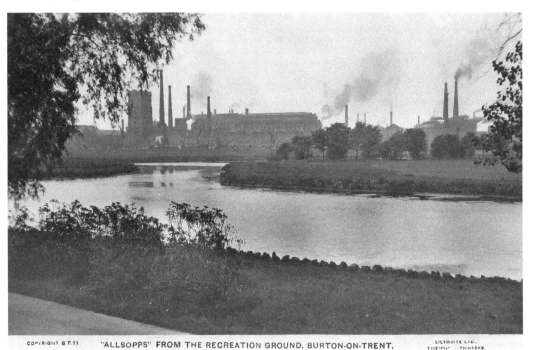

COPYRIGHT B.T.11 "ALLSOPPS" FROM THE RECREATION GROUND, BURTON-ON-TRENT. LILYWHITE LTD., PRINTERS.

The fame of Burton and its breweries made a postcard of them the perfect advert. This is looking from Stapenhill riverbank

Allsopp's loco sheds were located across Horninglow Street – to the left. This is the Brook Street crossing into the brewery.

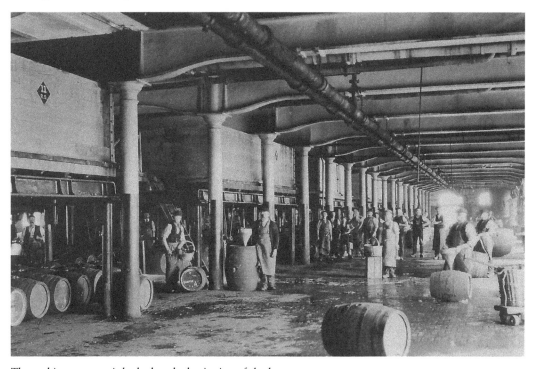

The racking room as it looked at the beginning of the last century.

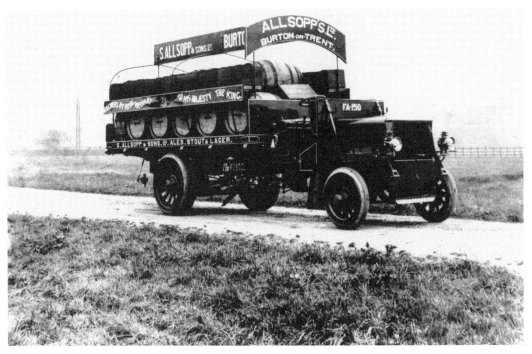

An early open-cabbed delivery wagon in a publicity shot.

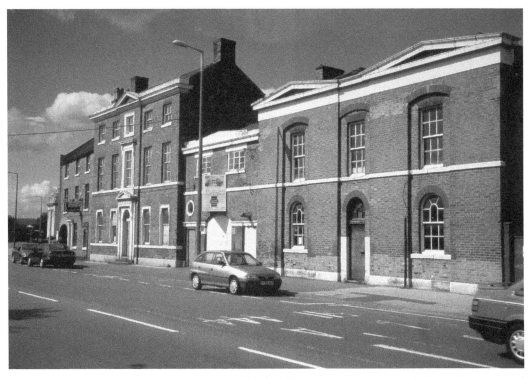

The large building on the right was originally Sketchley Brewery (1741–90), which was later acquired by Allsopp's.

Ind Coope Brewery

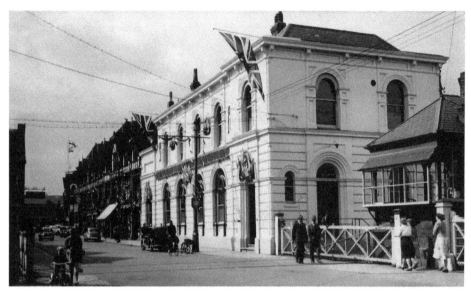

Ind Coope (1856–1997) Conference Centre dominated that end of Station Street. It was later known as the Guildhall.

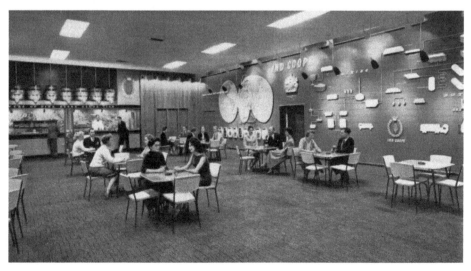

The bar and meeting area would be where parties visiting the brewery would have been entertained after a tour.

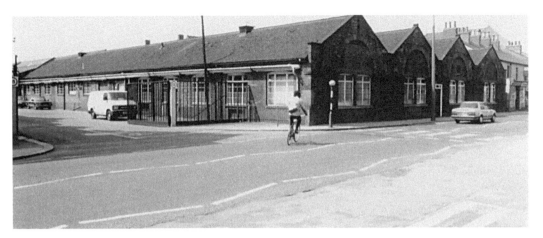

Directly opposite stood the vast stores of the brewery, as well as the architect's offices.

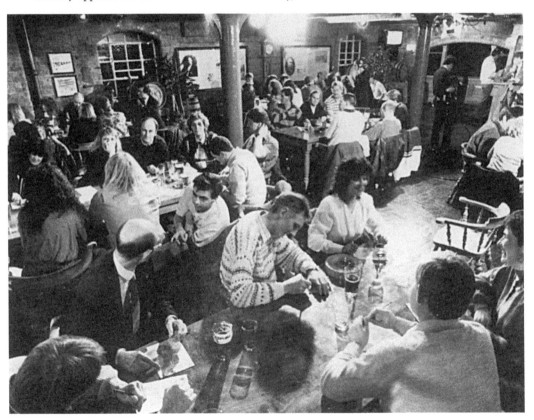

Part of the cellar area of B-block. Number 107 Station Street was converted to the brewery vaults to entertain visiting parties and events. Shown here is a radio quiz night organised by Radio Derby.

The next floor up had the modern restaurant for all the workforce to have a meal in pleasant surroundings.

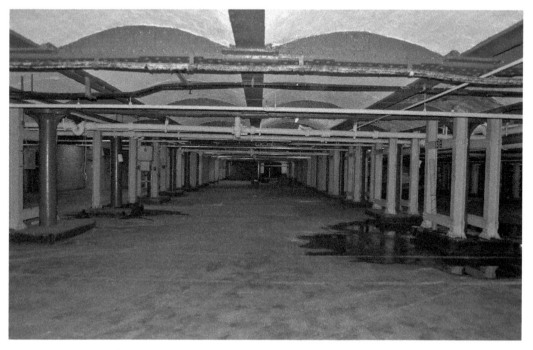

Running the complete full length of the B-block building, this cellar area would be completely full – at times with full barrels of beer. (Picture reproduced with the kind permission of Arthur Roe)

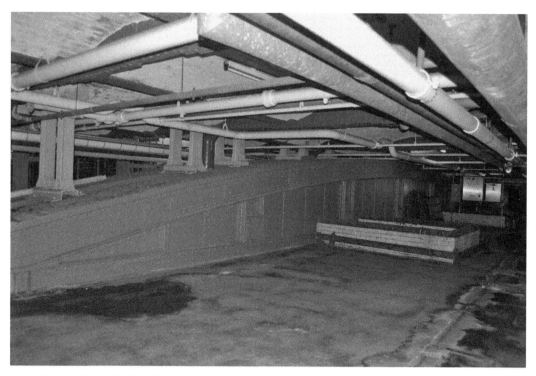

The 'lake', also in this cellar, was covered by this huge iron span over the well. (Picture reproduced with the kind permission of Arthur Roe)

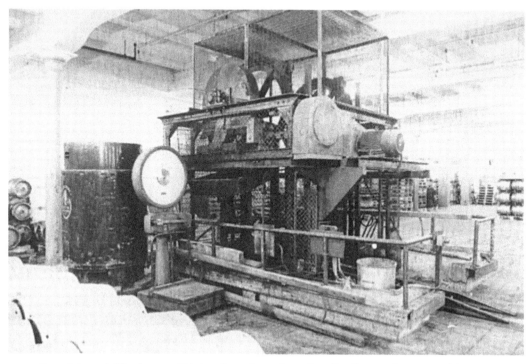

One of the cask lifts that would bring the casks up from the cellar floor to the waiting delivery wagons.

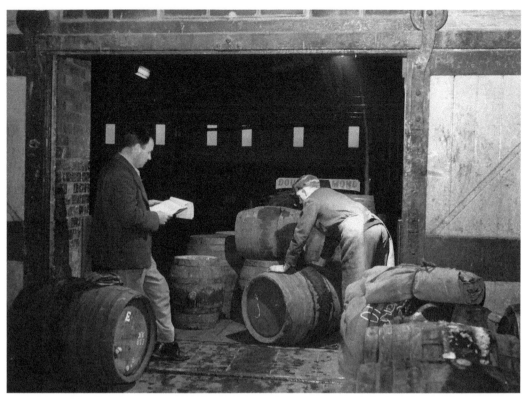

This dray, under cover of the Belfast roof, is almost complete of its load.

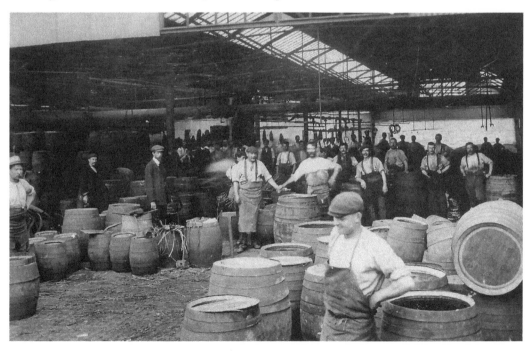

Workers can be seen taking a short break in this early view inside Ind Coope's cooperage.

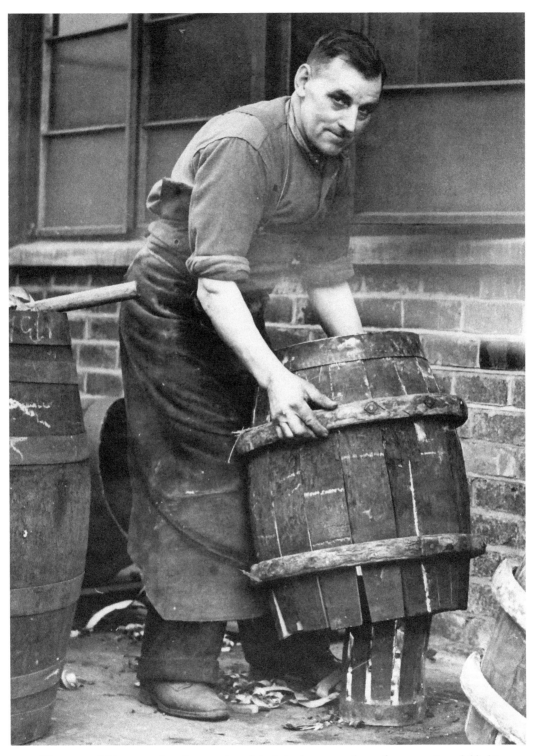

The name of this cooper is unknown, though he is in the process here of constructing a kilderkin – an 18-gallon cask.

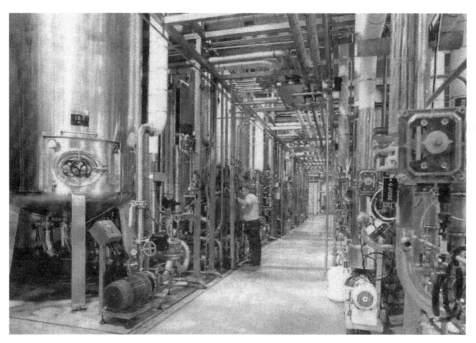

An avenue of stainless tanks in the filter room. The operative is Ken Crump.

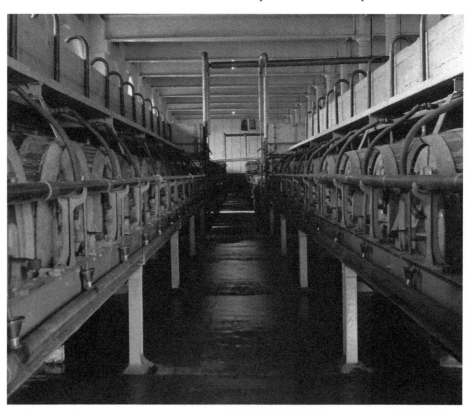

All the large breweries used the Burton Union System. The one shown here is Ind Coope's.

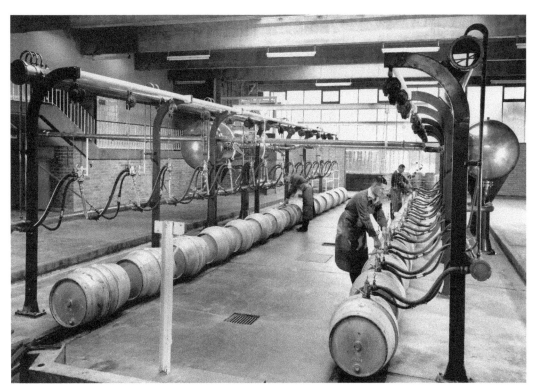

Cask racking was done adjacent to the keg plant. The chain track would take the full casks underground to the ale stores.

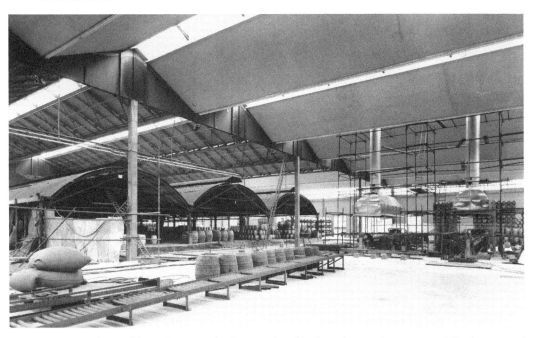

A new mechanised keg plant was built over the old plant during the 1960s, while the original kept producing.

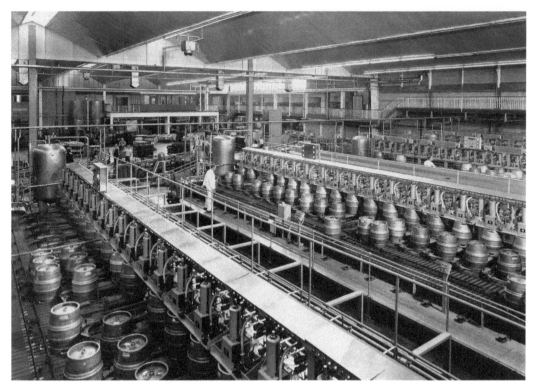

The four new keg lines in operation: line four – nearest the camera – only racked kills; line one –furthest away – only did firkins; and lines two and three could be altered to rack kills or barrels.

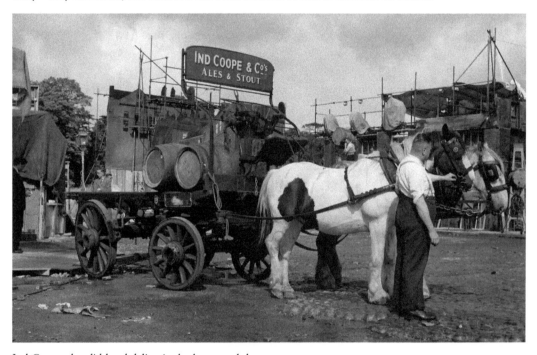

Ind Coope also did local deliveries by horse and dray.

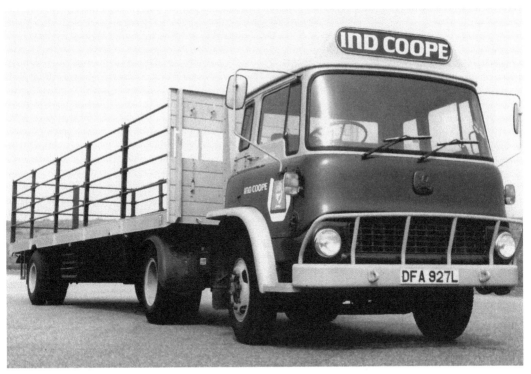

Modern delivery vehicles were soon a regular sight on Britain's roads, both articulated and flatbed.

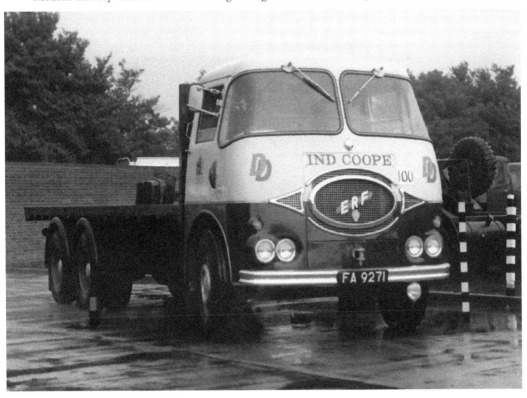

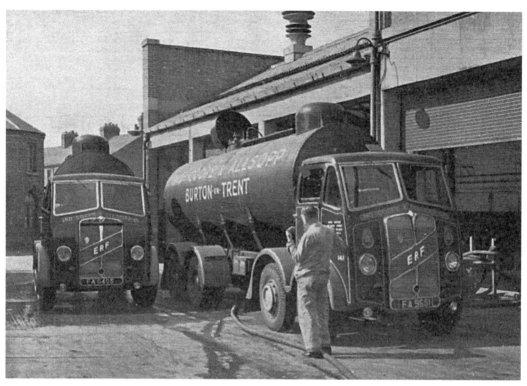

Bulk ale deliveries would be taken to various depots around the country.

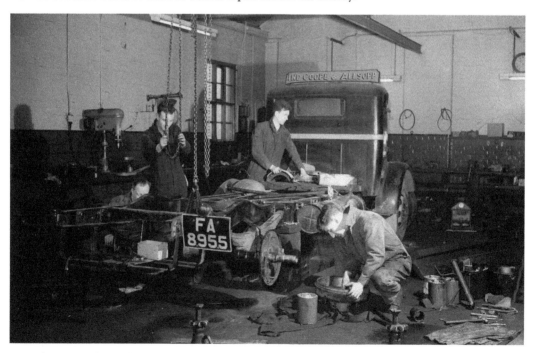

An early registered truck being overhauled by dedicated mechanics in the site garage at the bottom end of Grants Yard.

Trailers were stored on Ind Coope's Hawkins Lane site to make it quicker to move the trailers over to the main brewery. An internal bridge over Horninglow Street was built in 1985.

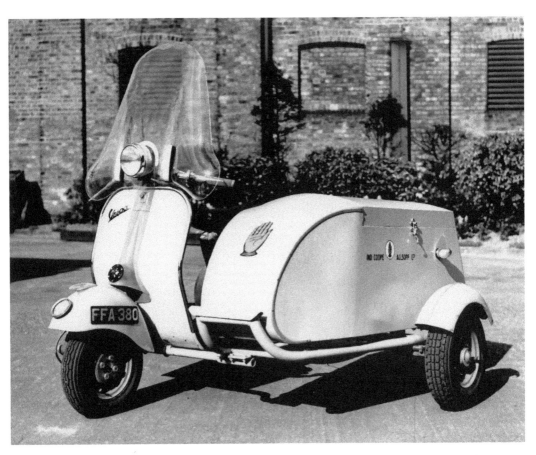

Certain department heads would be provided with scooters to aid movement between office and workplace.

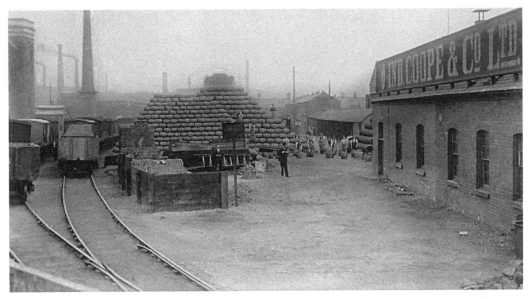

Horses had ceased to be used when this shot was taken, though it was still referred to as Stable Yard.

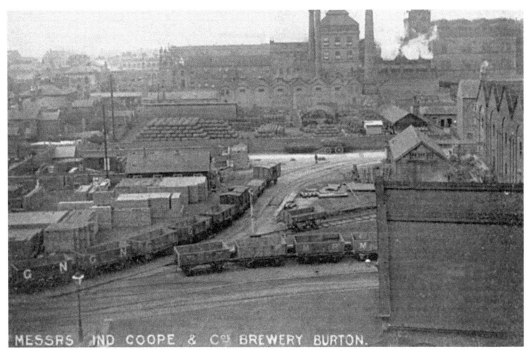

MESSRS IND COOPE & Cº BREWERY BURTON.

Although the title says Ind Coope, the area in front of the central wall was Bass; Ind Coope was above the wall.

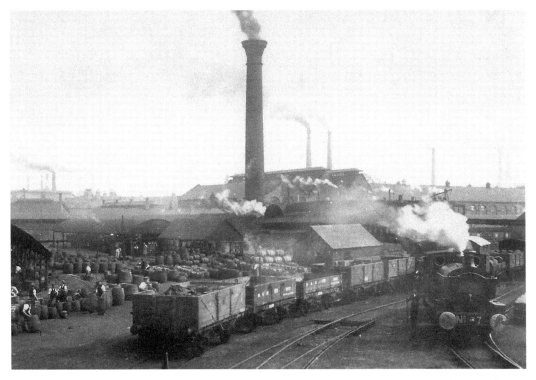

A perfect view of internal workings with coopers, ale loaders, various rail wagons and a steam loco.

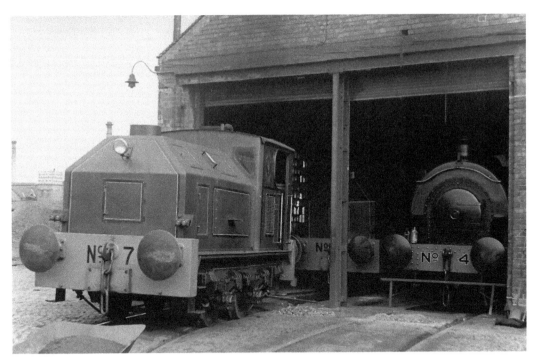

The Ind Coope loco sheds were across from the main brewery in Horninglow Street.

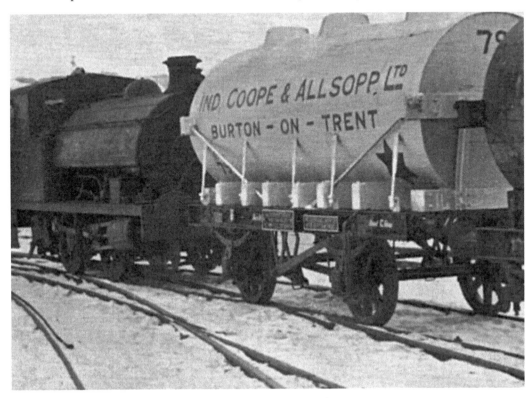

A bulk ale delivery is seen here leaving the brewery on a winter's day.

Packs of canned beer were also transported by rail.

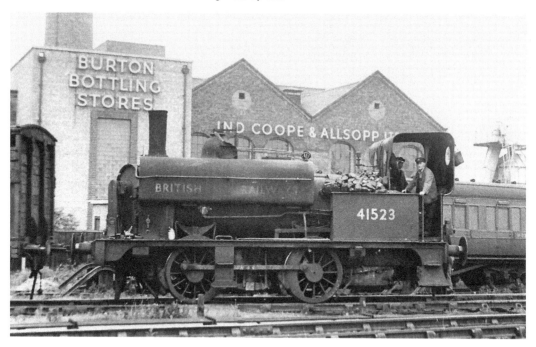

The old bottling stores stood in Curzon Street. Shown is the rear of the buildings looking from the main Birmingham–Derby line.

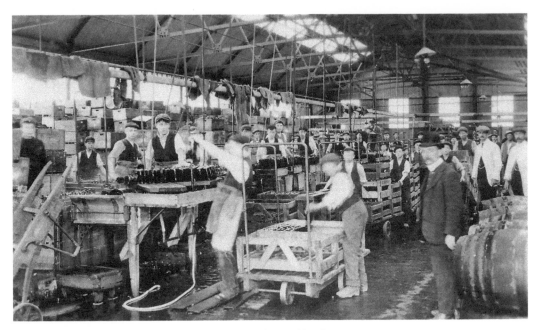

Early bottling was almost entirely done by hand, as depicted by this scene.

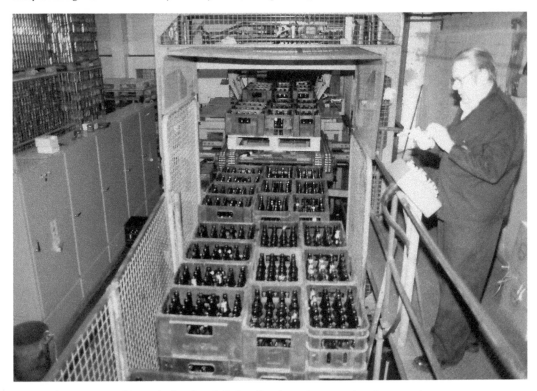

Empties being conveyed in to the bottling hall. Len Borsberry is overseeing the operation.

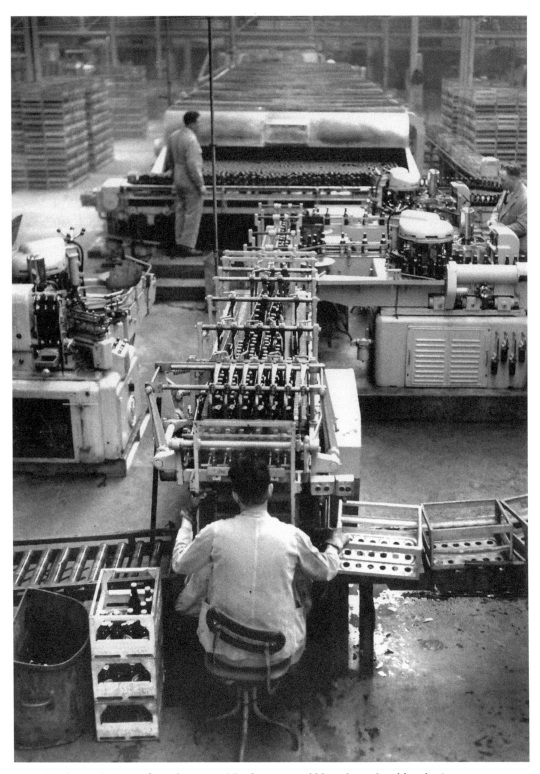

Another early view – from the 1950s. Metal crates would later be replaced by plastic.

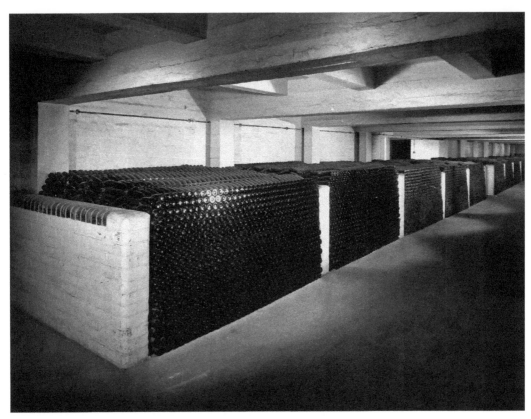

New consignments of bottle would be stored in the cellars until required for filling.

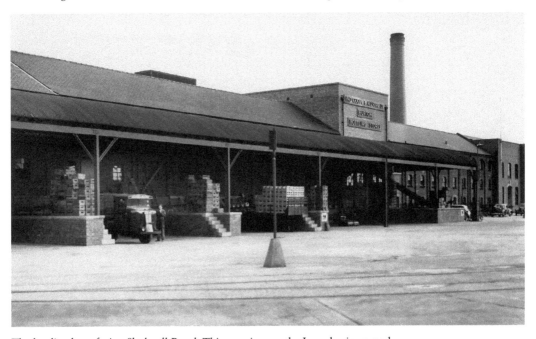

The loading bays facing Shobnall Road. This area is now the Imex business park.

Maltings

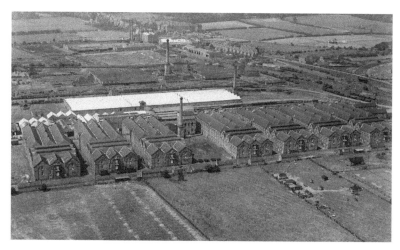

The vast expanse of Bass Shobnall Maltings. The lane at the front of the picture is now Wellington Road.

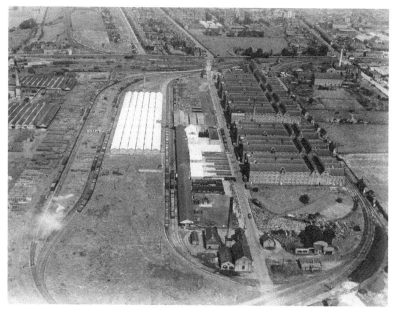

The bottling stores of Bass stood for many years alongside the maltings. It was all connected to the main site in town by the internal railway.

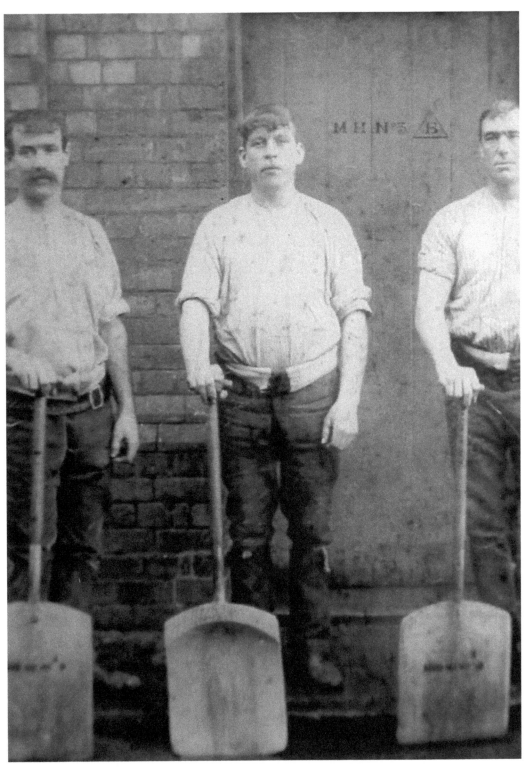

Three maltsters, probably 'Norkies' (migrant workers from East Anglia), about to commence work.

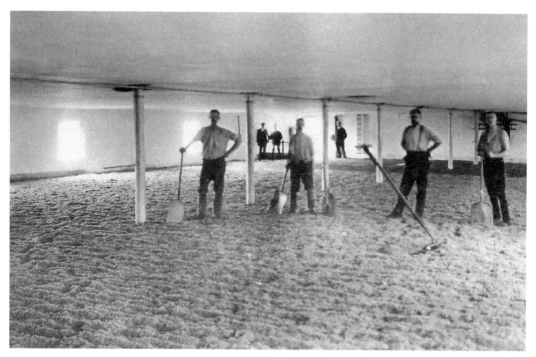

A quick pause for the camera on the malt floor. Wooden shovels and forks can be seen prominently.

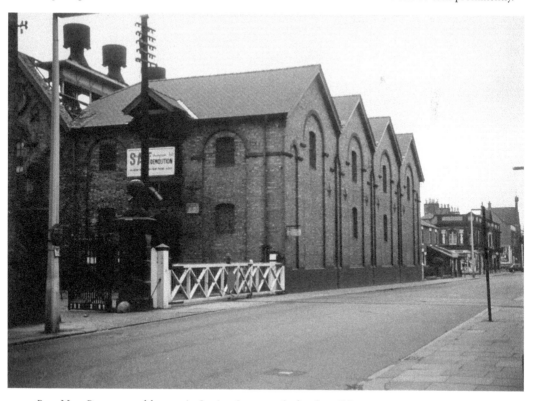

Bass New Brewery malthouses in Station Street ready for demolition.

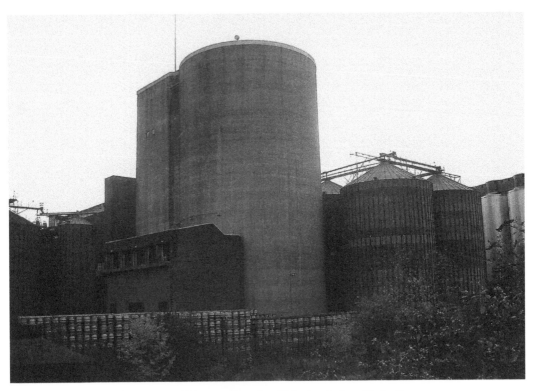

The Allied Brewery Malt Tower could be seen for miles. This view is from Derby Street.

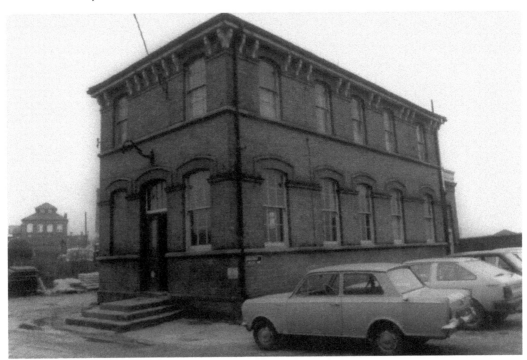

The Clarence Street maltings office block.

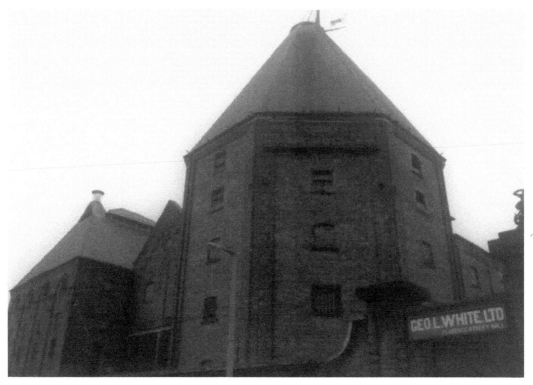

The Goat Maltings in Clarence Street was visible for miles.

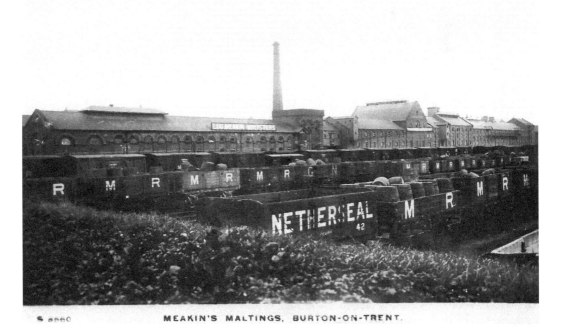

MEAKIN'S MALTINGS, BURTON-ON-TRENT.

Meakins Maltings stood in Anglesey Road and was well served by the railways.

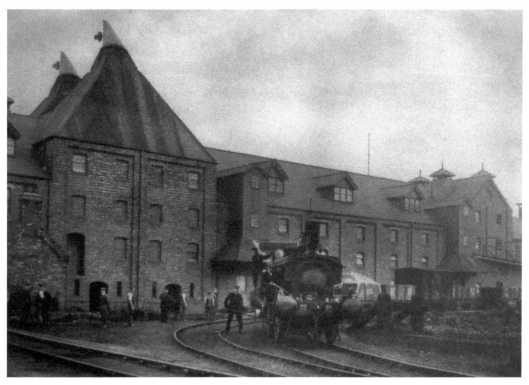

Peaches had their malthouses in Wood Street.

Despite not having been used as malthouses for over forty years, the Plough Maltings in Horninglow Street still survive.

A housing estate now stands on the land Allsopp's Maltings on Shobnall Road covered.

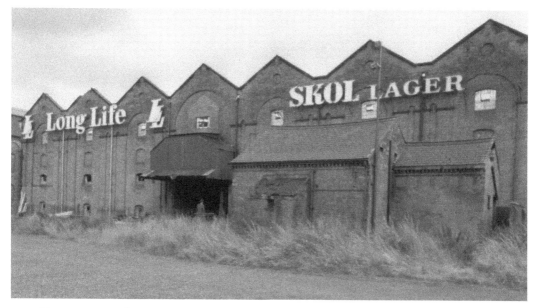

Not to miss an advertising opportunity, these huge signs at the rear of the buildings would be seen by passing trains.

Anglesey Road was also the site of Crown Maltings.

Salt's Walsitch Maltings in Wetmore Road were built in 1880.

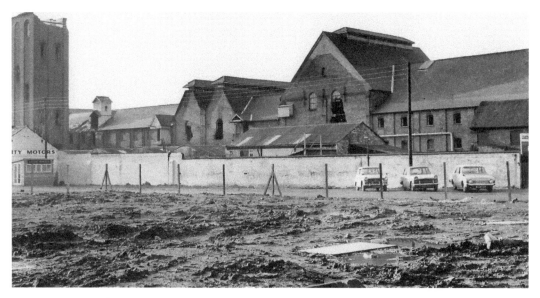

Marstons Maltings in Horninglow Street seen here shortly before being demolished. An Aldi store now stands here. (Photo courtesy of National Brewery Centre)

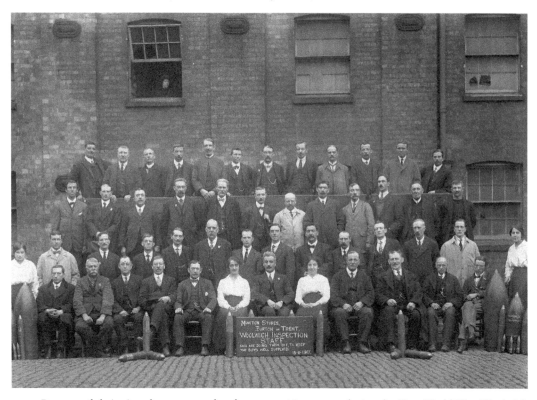

Because of their size, they were perfect for ammunition stores during the First World War. Woolwich Arsenal staff can be seen on an inspection visit to the bass site.

Floaters

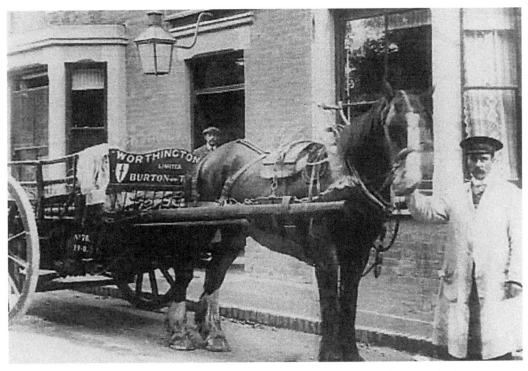

Above and opposite: Local public house deliveries would be undertaken in earlier times by brewery floaters. Featured here are those of Worthington, Burton, Brewery Co. and Bass.

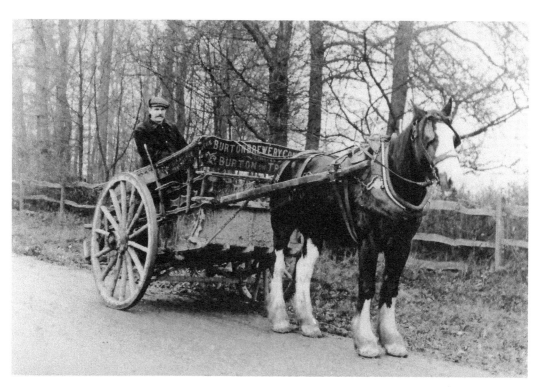

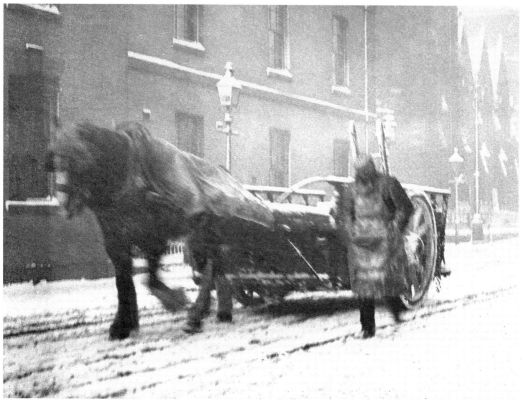

Women Workers

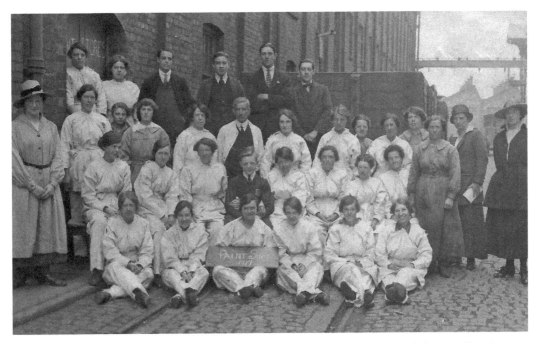

With men away during the First World War, this is the first time women are recorded as working in Burton's breweries. The women featured here were employed in the Bass paint shop.

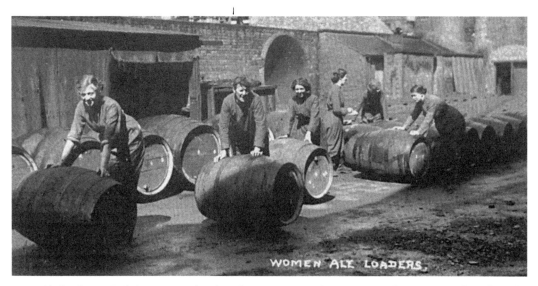

Ale loading at Ind Coope was also done by women. No gloves were used to prevent splints from the oak casks.

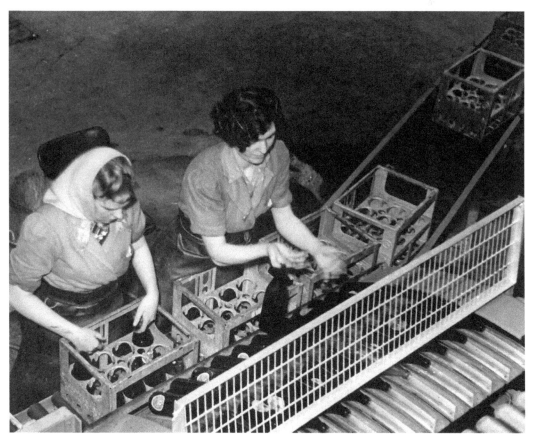

The bottling hall would also be a female environment, loading the returned bottles to the washers prior to refilling.

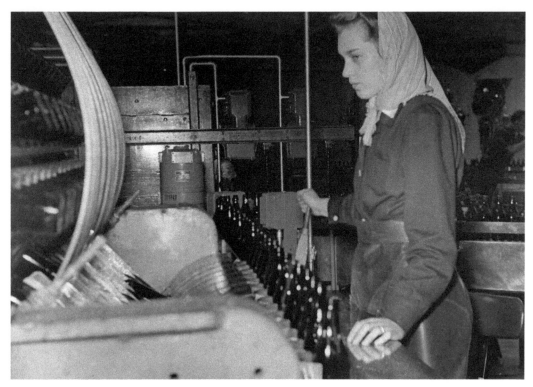

A worker shown here loading on to the filters after washing and sterilising.

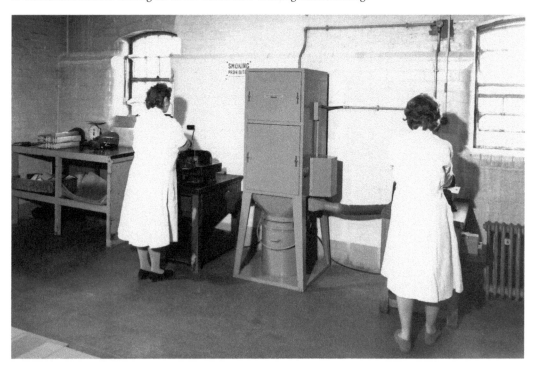

Label printing for the bottles was also done on site.

Fire

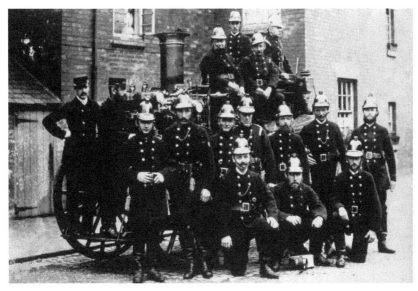

Bass fire crew from the early 1900s posing with the horse-drawn fire tender.

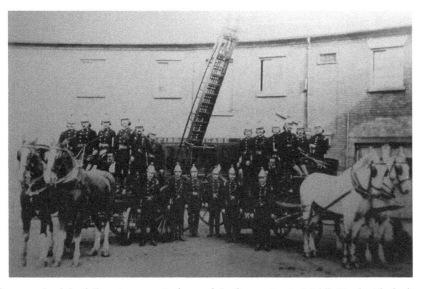

A photograph of the full station crew in front of the fire station in Middle Yard with the horses. Shires were not used to pull the tenders.

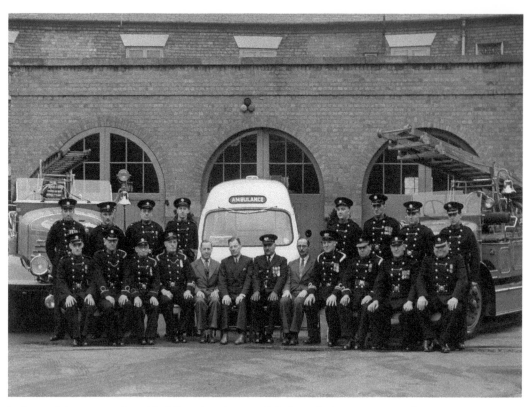

In front of the same station, this full service photograph is from the late 1950s or early 1960s.

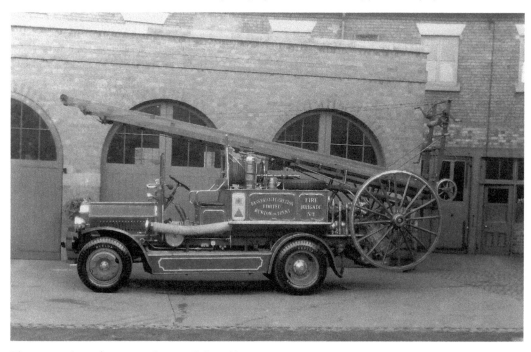

The open-style tender was used up until the mid-1960s.

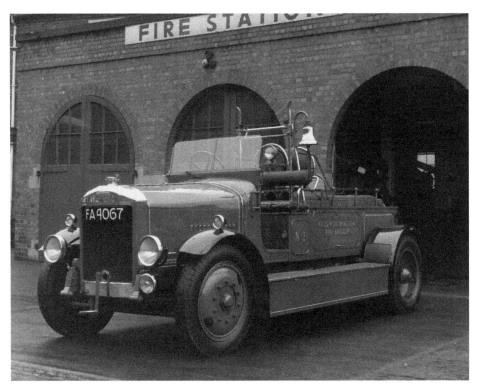

The ladder would be removed while garaged in the station.

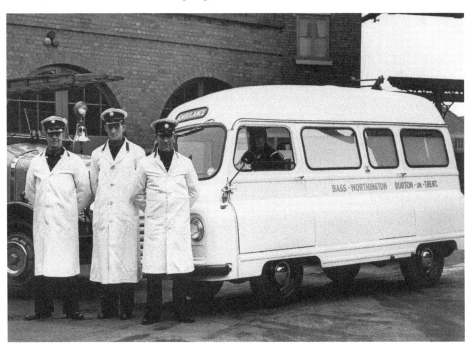

Four of the crew on page 104 would also man the internal ambulance. Seated inside George Mills and pictured from left to right: Ron Legrice, Stan King and Jim Appleby.

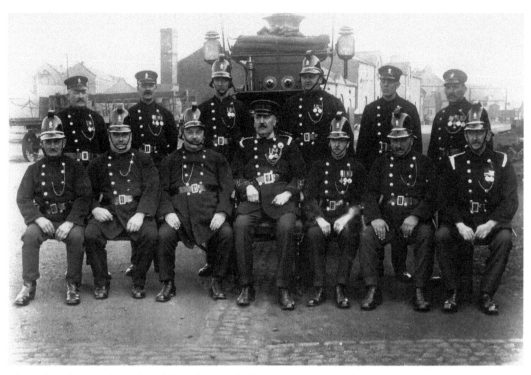

The early Ind Coope brigade in full uniform with the station superintendent.

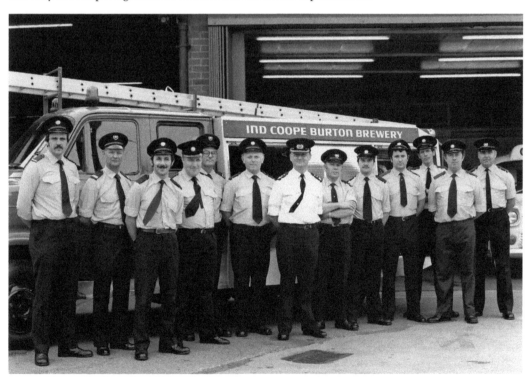

The last Ind Coope crew outside the fire station off Mosely Street.

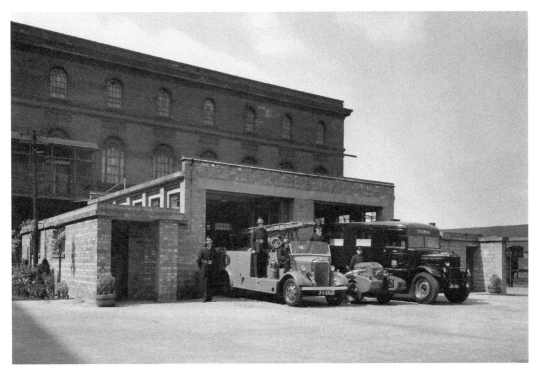

The early station was at the northern end of B-block. Here you can see open tender and a former army ambulance.

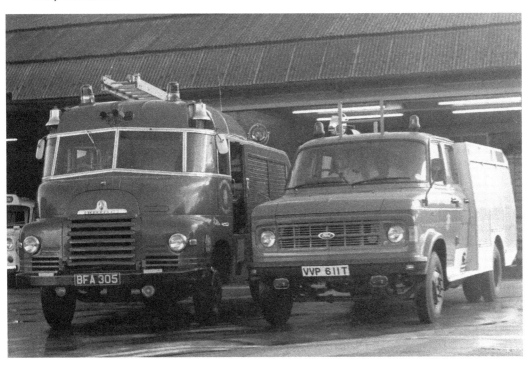

The later engines ready for any eventuality. This station is in Grants Yard.

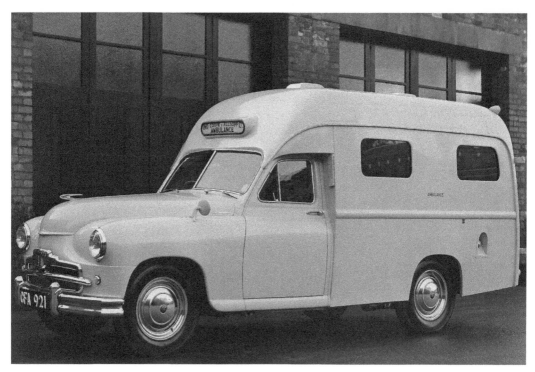

The ambulance was stationed next to the fire station.

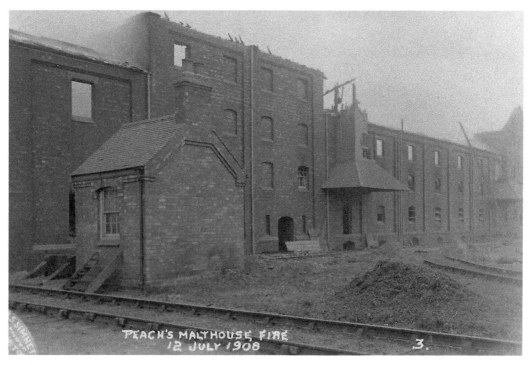

Peaches' devastating malthouse fire was fought by Burton Corporation crew, brewery crews and surround village fire crews.

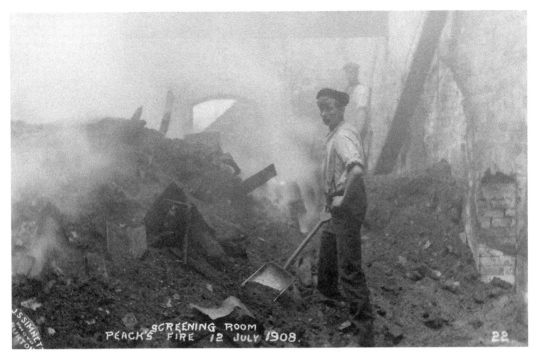

The damping down took many days and involved maltsters assisting the fire teams.

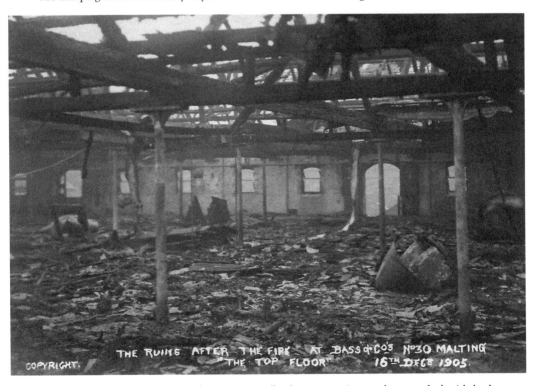

Above and overleaf: Malthouse fires were usually the most serious to have to deal with by brewery crew, as the destruction at Bass' No. 30 Malthouse at Shobnall shows.

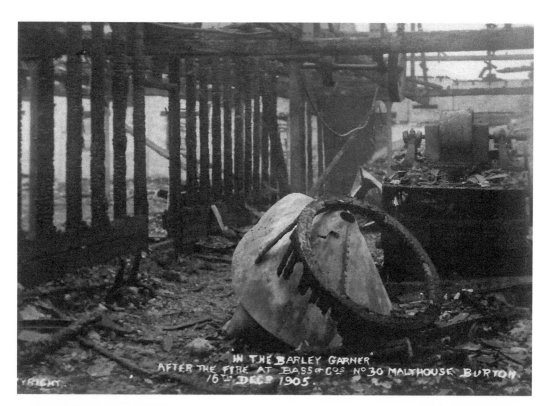

"IN THE BARLEY GARNER"
AFTER THE FIRE AT BASS & CO'S N° 30 MALTHOUSE BURTON
16TH DEC° 1905.

COPYRIGHT.

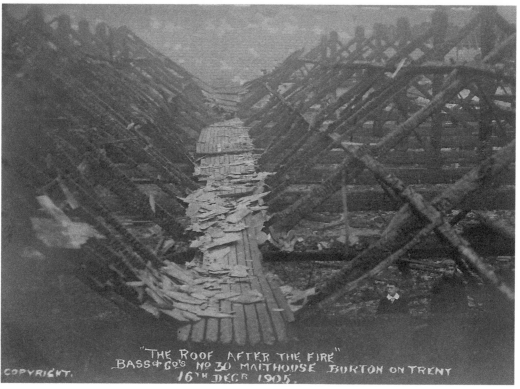

"THE ROOF AFTER THE FIRE"
BASS & CO'S N° 30 MALTHOUSE BURTON ON TRENT
16TH DEC° 1905.

COPYRIGHT.

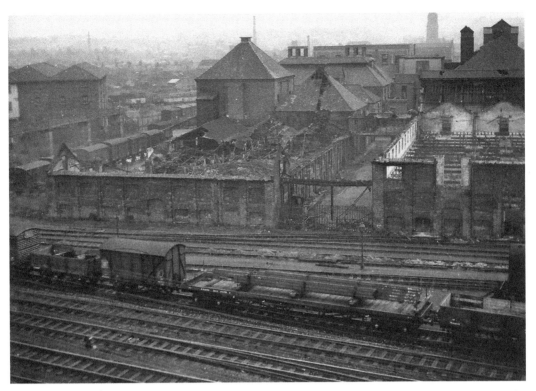

Ind Coope suffered the same fate. This is their malthouse, next to the main Birmingham to Derby railway line; the alarm was raised by a passing loco driver.

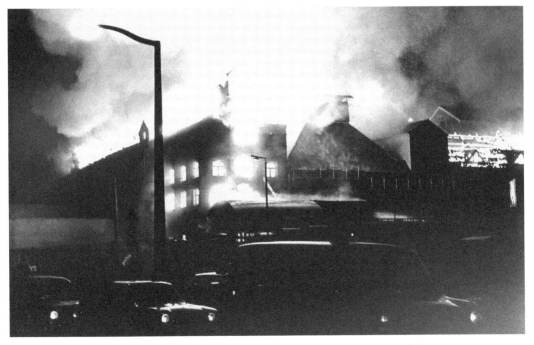

Adjacent buildings would soon become engulfed by flames, shown here at Ind Coope.

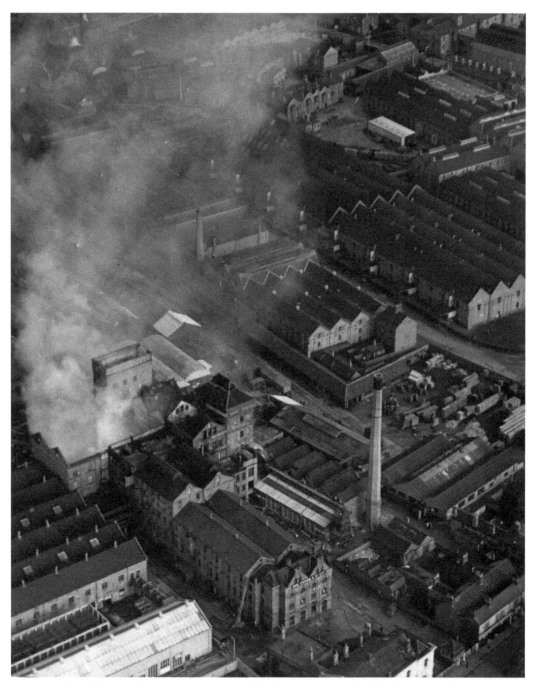

An aerial view of the 1954 Ind Coop hop store on Station Street, just visible in the bottom right.

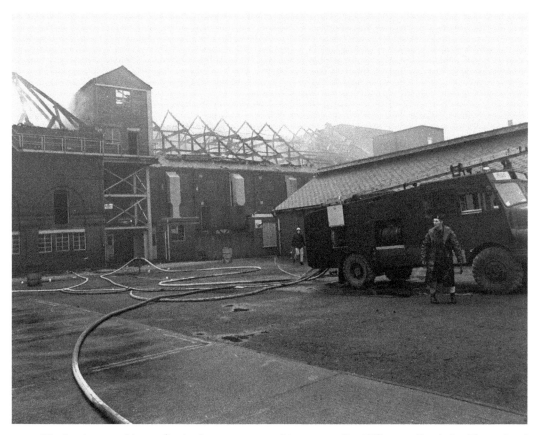

The last large malthouse fire in the town occurred in 1977 at Bass' Wetmore Road site. The national fire strike meant that the army's Green Goddess tenders attended.

Advertising

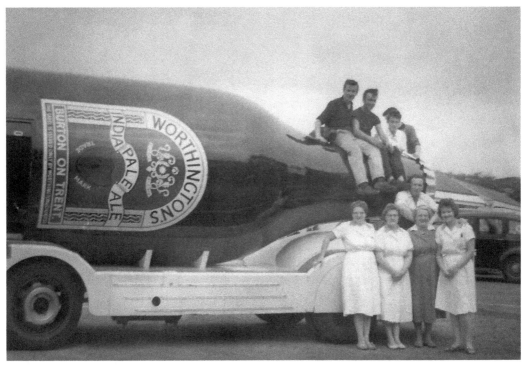

Above and opposite: The Bass advertising bottle vehicle would have beers displayed at various times. It can be seen here displaying Worthington, Pale Ale and Bass.

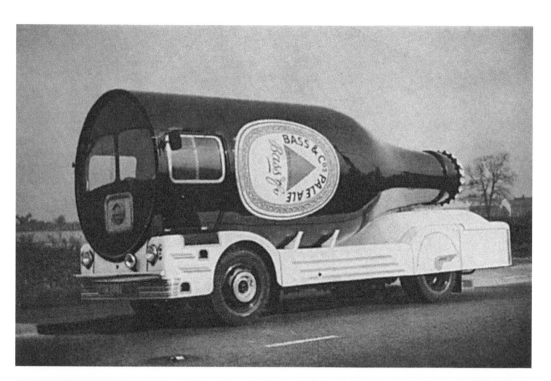

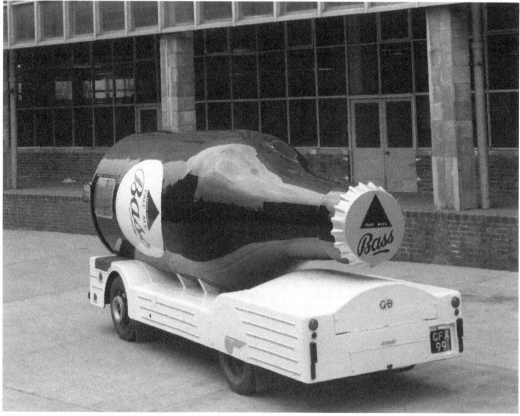

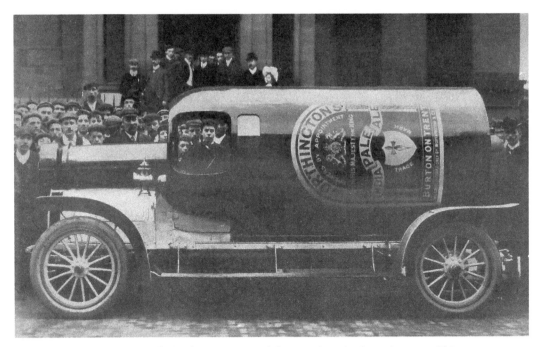

Worthington's began to use vehicles for promotion of their products in the early 1900s. This was one of the first to be delivered.

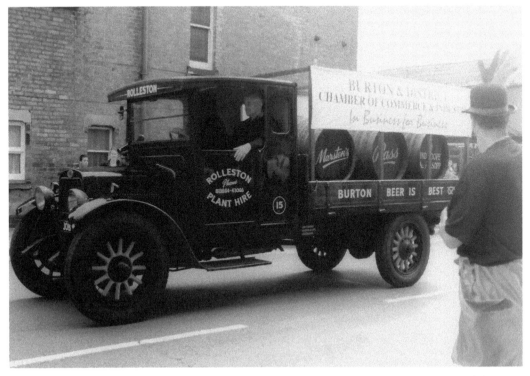

A local plant hire company are happy to promote three of Burton's famous breweries at one of the town parades.

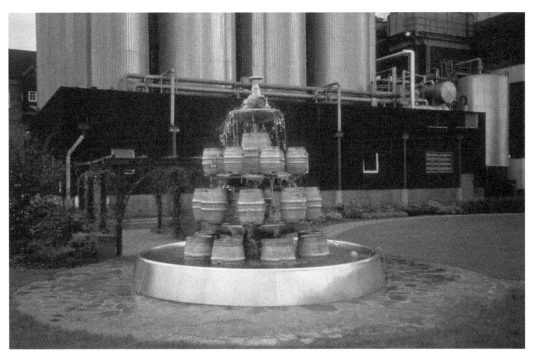

The Bass cask fountain in its original location at the corner of Cross Street and Station Street.

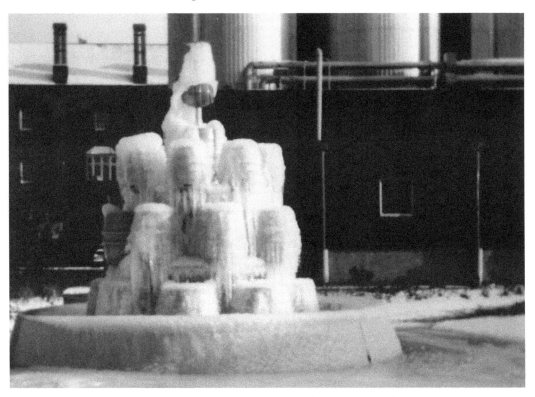

An impressive feature, it looked even more eye-catching following a hard frost.

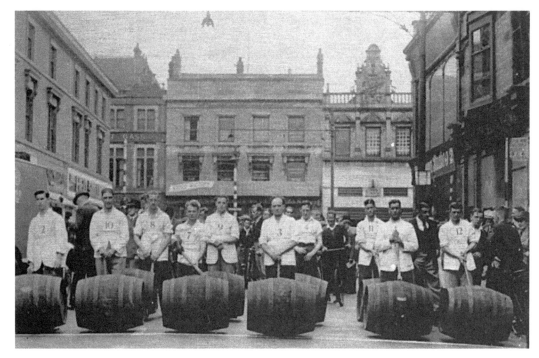

The 1944 Burton barrel-rolling race. Participants are shown here at the starting point at the junction of High Street and Station Street. All breweries in town would send competitors.

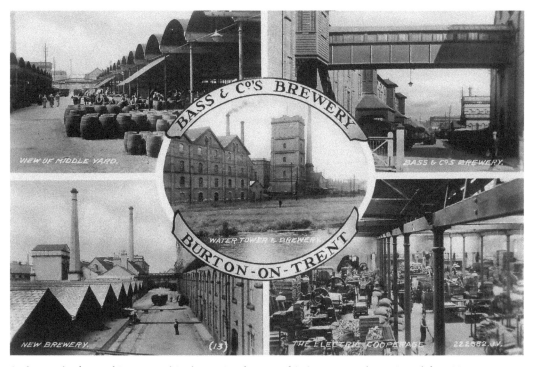

Such was the fame of Burton and its breweries that a multi-view postcard was issued for visitors to send back home.

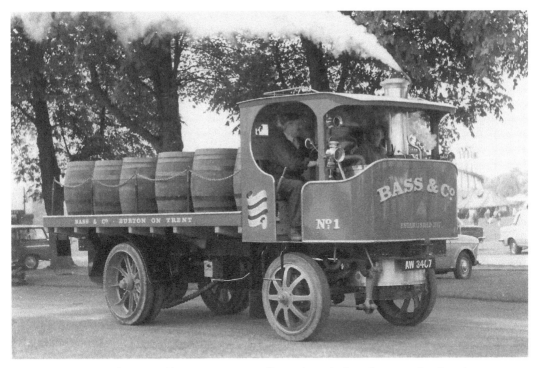

The Bass steam lorry would go out to steam rallies and carnivals to do promotional work.

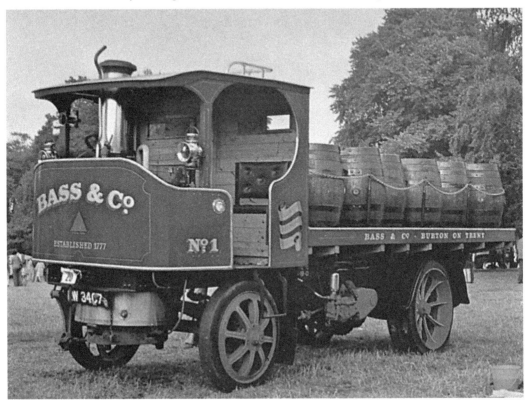

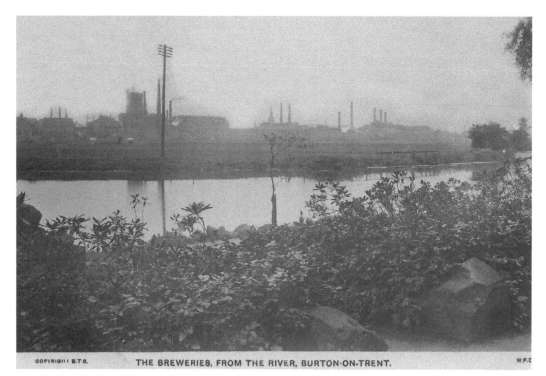

THE BREWERIES, FROM THE RIVER, BURTON-ON-TRENT.

The six breweries that stood next to each other in High Street also featured on postcards. The image on this one was taken looking from Stapenhill.

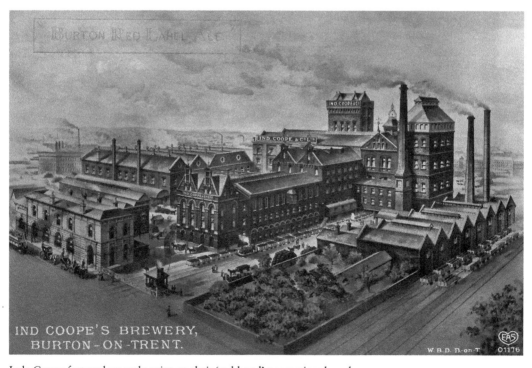

IND COOPE'S BREWERY,
BURTON-ON-TRENT.

Inde Coope featured an early print on their 'red hand' promotional card.

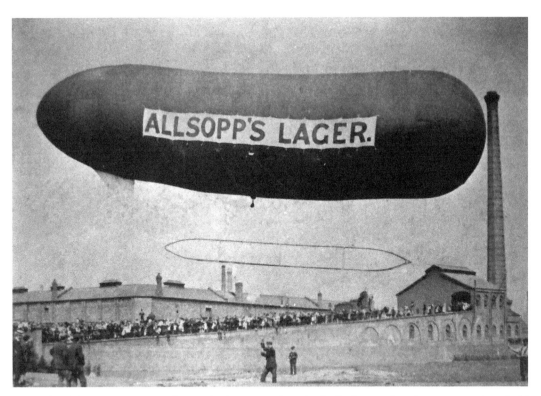

The old town incinerator plant and a huge crowd are in the background as the men struggle to hold the advertising balloon.

Dominating the town skyline for many years, telling the time and temperature, the old Allied Brewery Malting Tower has now disappeared.

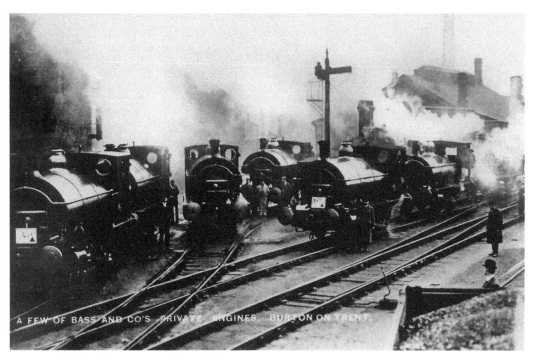

Bass proudly show their 0-4-0 saddle tank locos to advertise their delivery expertise.

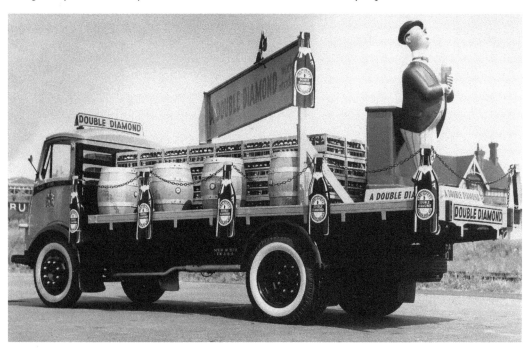

Inde Coope would send a decorated delivery dray to the Lichfield Bower procession for many years.

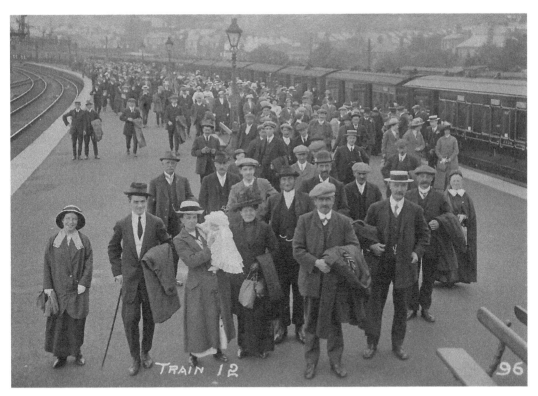

Here are two images of the Bass trip to various seaside resorts in the early years of the last century. As well as being a day out for the workforce and their families, reports by local and national press agencies made for a perfect PR exercise.

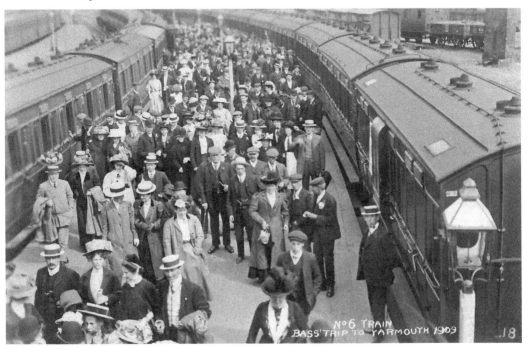

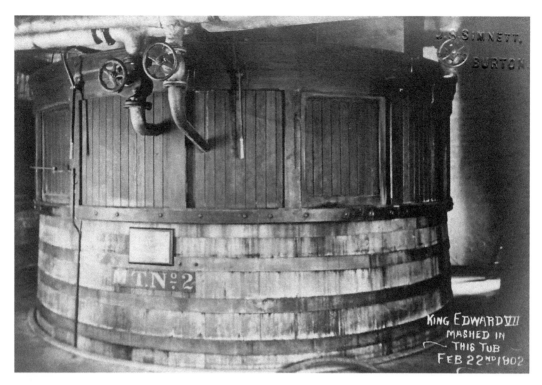

J.S. SIMNETT, BURTON

M.T. Nº 2

KING EDWARD VII
MASHED IN
THIS TUB
FEB 22ND 1902

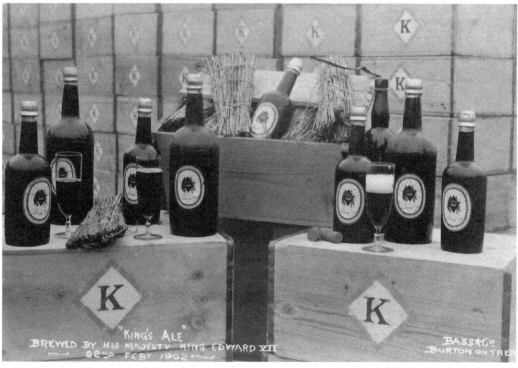

"KING'S ALE"
BREWED BY HIS MAJESTY KING EDWARD VII
22ND FEBY 1902

BASS & Cº
BURTON ON TRENT

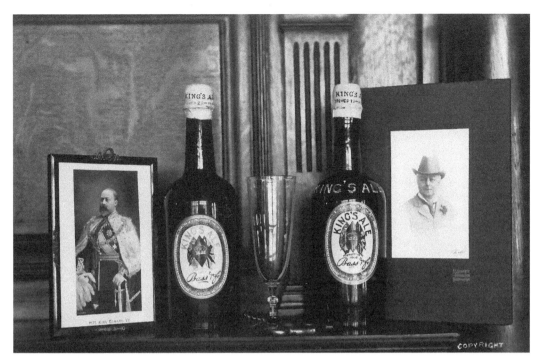

Above and opposite: Edward VII's visit to the brewery in 1902 made for a perfect advertising opportunity. As well using the mash tun, he started the brew of the ale featured here. Posed still life samples also made ideal adverts for the brewery.

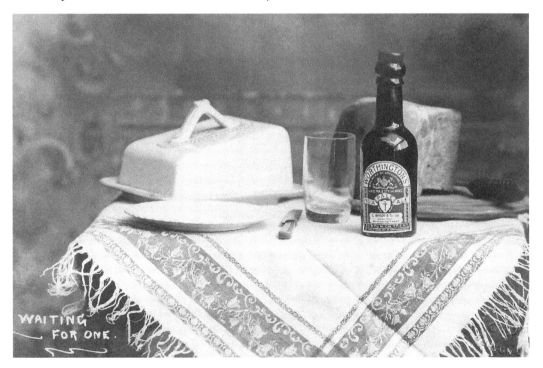

Worthington India pale ale together with bread and cheese also feature as a still-life composition.

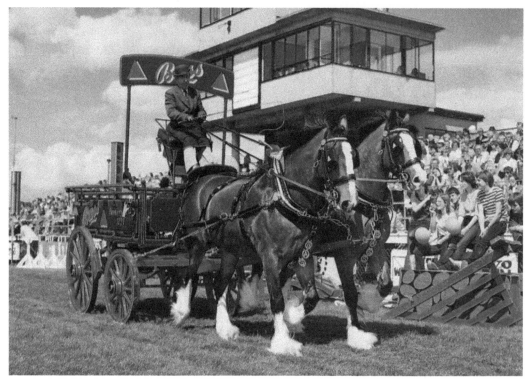

Heavy horse parades around the country were ideal promotional opportunities for the brewery.

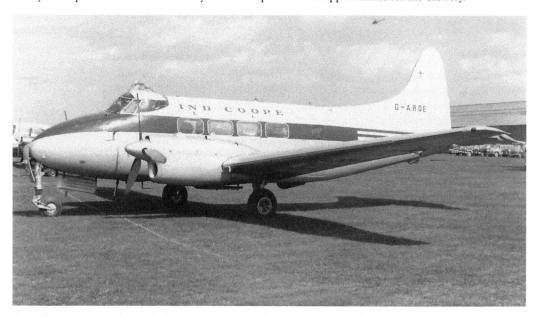

As well as providing fast links between the midlands and London for brewery executives and VIP visitors, Inde Coope's *de Havelland Dove* aircraft provided perfect aerial advertising.